ME & OTHER WRITING

ME & OTHER WRITING
MARGUERITE DURAS

TRANSLATED BY OLIVIA BAES & EMMA RAMADAN
With an introduction by Dan Gunn

DOROTHY, A PUBLISHING PROJECT

This work received support from the French Ministry of Foreign Affairs and the
Cultural Services of the French Embassy in the United States through their publishing
assistance program.

Cet ouvrage a bénéficié du soutien des Programmes d'aide à la publication de l'Institut
français.

First Edition, 2019
ISBN: 978-1-948980-02-9

Photograph on cover:
Maruerite Duras In France In October, 1984. By Louis Monier.
Louis Monier / Gamma-Rapho / Getty Images

Design and composition by Danielle Dutton
Printed on permanent, durable, acid-free recycled paper in the United States of America

The publisher wishes to thank Red Samaniego and Christina Wood Martinez

DOROTHYPROJECT.COM

CONTENTS

Introduction VII
Publisher's Note XVII

Flaubert Is . . . 1
The Sound and the Silence 13
My Mother Had . . . 19
Atlantic Black 30
Letter to Centre Rachi 35
Translation 37
I Thought Often . . . 39
Horror at Choisy-le-Roi 48
Nadine from Orange 57
Reading on the Train 67
True Appearances 78
The Men of Tomorrow 82
The Right, Our Death 88
The Horror of Such a Love 90
Me 93
Summer 80 95

Notes & Contexts 171
Translators' Afterword 175
Biographical Notes 181

INTRODUCTION

THE WORLD INSIDE ME

In one of the essays included in the present collection, entitled "My Mother Had," Marguerite Duras writes feelingly of her mother's profound influence upon both her life and her work. She describes how her mother was a bundle of violent contradictions—lucid yet crazy, punctilious yet negligent, passionate yet unaffectionate—and suggests that it is precisely her contradictions that made of her such a wonderful *character*. By this she means not that she was a fine personality or a splendid (or even adequate) mother, but rather that she was a great figure of the sort one finds *in literature* ("un grand personnage" is Duras's French original); so ideally suited is she to fiction that she could step directly into it with practically no elaboration or inflation. Nobody who has read *The Lover*, where the mother is so memorable and equivocal a presence, mendacious and puritanical at once, or who has read the fullest portrait Duras gave of her, in the early novel *The Sea Wall*, can doubt the truth of what her daughter concludes towards the end of her own life, writing in 1988 when she was seventy-four years old. Yet, if the insight into Duras's family, and the way in which her family shaped her

writing, is typical of what this splendid collection of her essays and occasional or journalistic writings has to offer, so too is the remark that follows: "But she is not the main hero of my body of work, nor the most permanent. No, I am the most permanent." In all the pieces gathered here, which with few exceptions first appeared in the public prints, the ostensible focus on the world and its politics, its scandals, its crimes, and its injustices, cannot obscure for long the fact that they are also—at times latently, at other times explicitly, obsessively, egotistically—about none other than Marguerite Duras herself: "Me," as one article succinctly puts it in its title.

The contents of the present volume are drawn from three sources (which themselves drew on many more). The longest piece, or series of pieces, was originally published in December 1980 under the name *L'Été 80* (a title I have always pronounced in my head as the rhyming *L'Été eighty*). As she explains in her foreword to the ten articles that make up the whole, Duras was commissioned by the then editor of the French daily, *Libération*, to submit a journal which lasted between 16 July and 17 September of that year, texts which were later assembled into a book dedicated to the young man who had made a dramatic appearance in her life during that summer, Yann Andréa, who appears as the "you" of several of the later pieces. The first of the other two sources was published some months later under the title *Outside. Papiers d'un jour*. (Could it be that Duras's choice of an English title influenced my hearing the

French *quatre-vingt* as *eighty*?) Duras had published scores of jour-
nalistic articles over her career, and in *Outside* she chose to repro-
duce fifty-nine of these. Four years later this volume was followed
by another, subtitled *Outside 2* (main title *Le Monde extérieur*). In
the preface to the first volume, Duras explains that her reasons for
writing these occasional pieces are fourfold, and as these reasons
subtend the entire contents of the present volume, it is worth reit-
erating them here.

 The first reason, Duras says, is to take her out of her private
literary space, out of her room, in an escape from the intense focus
on interior processes that working on a fiction eight hours per day
required of her. She adds that, in taking her out of her familiar writ-
ing-zone, what she found was "my first cinema"—by which I take
her to mean that her journalistic articles constitute a step on her
move away from fiction to almost exclusive work for cinema. This
shift lasted for around a decade, during which time Duras more
or less abandoned writing that was not for the cinema; the books
L'Été 80 and *Outside*, if they retain some features of her cinematic
writing, constitute a *retour en force* of the written word, a *retour*
that would reach an apogee in her publication four years later of
the work that would prove the most popular of her entire career,
L'Amant (*The Lover*).

 A second reason Duras offers for writing journalism is sim-
pler: for money. It was indeed only with *L'Amant* that Duras could

cease to worry about finances—or worry about them differently; the articles she wrote for *Vogue* she describes as being "alimentary."

A third reason is that, having been asked to write articles, by various editors, and having accepted, she felt obliged to meet her deadlines—a commitment that, when one knows how seriously alcoholic Duras was for much of her adult life, is not nearly as self-evident as it sounds.

The fourth and final reason deserves to be given in some detail. For it outlines the extraordinarily labile quality not only of Duras's commitments, but also of her sentences. What she says illuminates all the texts assembled here, and also gives a convenient sample of the difficulties any translator faces—in the following instance, me—when attempting to render her prose into English, with its supple syntax, its often uncertain referents, its mixing of registers, its comma-splices, its stream of a consciousness that is constantly straining towards an ideal of *un*consciousness:

> The further reasons why I have written, why I do write in newspapers derive also from the same irresistible movement that took me towards the French or Algerian resistance—anti-governmental or anti-militaristic, anti-electoral, etc., and which took me also, *like you* and *like everyone*, towards the temptation to denounce what is intolerable within injustice of any order whatsoever, whether undergone by an entire people or by a single individual, and that took me again

towards love when that love passes into madness, when it abandons prudence to lose itself even as it is discovering, towards crime, dishonour, and indignity, and when the imbecilic judicial system and society see fit to cast judgement—upon that, upon nature itself, as if they could judge tempest or fire.

It is not just that the political is, for Duras, always personal, or the personal always political. It is that both personal and political are founded upon what she sees as a fundamental impossibility —the impossibility, as it may be, to live honestly or meaningfully within the conventions dictated by society, with its religions, its laws, its tyrannies, its grammar, its syntax. The suffering caused by this impossibility is never far from her mind, when it is the job of artists—of writers supremely, but not uniquely—to make of this suffering forms which are, in their utterly unnatural doubling of the world, testaments to what makes us uniquely human. "To be a genius," she writes in her essay "The Men of Tomorrow," "is to take the genius outside of oneself and put it on a canvas or inside a book."

*

There is nothing obviously transgressive in the premise of *Summer 80*: an elderly woman, seated at the window of her apartment in Trouville on the Normandy coast which overlooks the beach, is taking the time to comment on the inclement summer weather,

the turning of tides and the influx of holiday-makers, and above all on the sea—that same sea (and not the same) which appears as a central figure in so many of the author's fictions, and which will reappear in the fictions yet to be written during the 1980s and '90s.

It's true, the weather itself is recalcitrant, refusing to offer the holiday-makers the sunlit pleasures they were expecting. It is a melancholy beach indeed that appears here, at least in the first five entries to *Summer 80*, where a communal expectation of distraction and pleasure has been massively disappointed. Duras's sea has never been of the jolly variety, in fact, vector as it was from early in her career—most obviously in the early novel *The Sailor from Gibraltar*—of an unassuageable, almost amniotic, longing. And it is into such weather, such a seascape—so different from those of the Impressionists who immortalised these beaches, or indeed from Proust's Balbec (though Proust does appear here, as a further incarnation of impossible longing), that Duras inserts her protagonists: a young lost boy with gray eyes and a young equally lost woman supposed to supervise him. The two meet regularly under Duras's window, though the author's gaze soon penetrates far beyond what is credible within the conventions of journalistic verisimilitude, to include the pair's conversations, their shared stupefaction when faced with social obligations, their barely licit love. Duras was of course no stranger to disparities in age between lovers, and will soon write explicitly about what she lived as a teenager with an older wealthy

Chinese man; the texts of *Summer 80* have an almost premonitory role, too, as into her life was about to intrude a man some thirty-eight years her junior, with whom she would spend her remaining years. Yet even so—and perhaps additionally today, in an age where pedophilia has moved from the shadows into the glare of forensic attention—the love shared between an adult and a child is startling; Duras herself believed it was one of the most beautiful love stories she had ever written. As is, indeed, the story the supervisor recounts to the boy, of a friendship between a shipwrecked boy named David and a shark that has devoured his parents. It was, apparently, a tale Duras used to tell her own son.

A tale haunted by violence and the threat of further assault: the sort of children's story for which Duras offers no apology, convinced as she is, as she states most explicitly in "Me," that a world without violence is inconceivable, particularly when the greatest violence of all is that experienced within. It is from this turbulent context that emerges the other great motif of *Summer 80*, which is of the Solidarity movement gathering momentum in the Gdańsk shipyards. Here too Duras's writing is prophetic, as she realises far more clearly than many commentators of the day just how important this movement is going to prove to be. Indeed, into it she pours her fantasies of heroic insubordination, her disappointed hopes of the communist she once was, as well as her loathing of all totalitarian regimes, to the point where Gdańsk becomes the object of a sort of ideal and

idealised love—a politics of love being the only sort in which, at this late stage in her life, the author appears able to believe.

*

In the articles that precede *Summer 80*, taken from *Outside* (I and II), the political turn is one that repudiates all totalizing theories, ideologies, and pretensions, and seeks to return to the intense vulnerability and precariousness, the receptivity and spontaneity, that Duras believes to be the true condition of the human subject, a condition most frequently embodied by women and children—much more rarely by men. Of if by men, then by *outsiders*—it may be hard, now, to conceive of Yves Saint Laurent as an outsider, but it is clearly, and even somewhat convincingly, in this role that Duras casts him in the essay devoted to him and his fashion.

Once again, therefore, violence is never far distant, as outsiders are almost bound to provoke derision and hostility. Like her almost contemporary to whom she is sometimes likened, Muriel Spark, Duras was an avid reader of what the French call *faits divers*—true tales of petty and not-so-petty crime, often set in claustrophobic pressure-cooker families or communities. She was fascinated by the case of André Berthaud, who killed himself spectacularly after being accused of having violated a twelve-year-old girl; Duras paints a sympathetic portrait of him through interviews conducted with his family. She tells of Simone Deschamps who was accused

of having murdered her lover in a "crime of passion" that occurred after years of indulgence in sex games. Her defence of these poor souls, these *pauvres types* who have run foul of the legal system, feeds directly into her masterpieces which emerged from such reporting, *Moderato Cantabile* and *L'Amante anglaise*, shocking and profoundly humanizing novels that reverse conventional assumptions about victimhood. Nor is violence ever far distant from that other theme which haunts her essays as well as her fiction, such as was vented upon the Jewish people during the 1930s and '40s. Duras had, of course, her own personal investment in the fate of those deported to the concentration camps, as readers of her remarkable memoir *La Douleur* will know: her husband Robert Antelme survived Dachau, but only just. But for her, civilization itself has in some ineradicable sense failed to survive the Shoah. The role of the artist has become that of bearing witness, precisely, to the repercussions, on every level from the most public to the most private, of that breakage.

Whether a painter, a fashion designer, a filmmaker, or a writer, the artist has a duty that aligns with what Samuel Beckett outlined in the immediate post-war years—a duty to fail "as no other dare fail." (It is no coincidence that in the late 1950s Beckett was urging his friends to see the theatrical performance of Duras's *Le Square*.) Art is the realm that testifies to the fact that for humans it is not sufficient merely to live, breathe, consume, breed, die. Art, in its

primordial re-presentation of the world, signals the suffering engendered by our outside-ness to nature. It cannot, if it is to be genuine, belong to a realm of potency or knowing; the artist is engaged, eternally and infernally, but also joyously—even ecstatically—in a creative process that cannot recognize itself. It is a process—and not for nothing does Duras remark on how close she was to Maurice Blanchot, whose views on the artist she echoes—that in one sense is of the world but in another draws its maker out of this world. The artist is drawn into a state of intensely anxious scrutiny of both self and world that, if the conditions are right, may give rise to a voice, a narrative, a vision, that hails from somewhere far beyond the artist's ken. Violent contradiction is just the tip of the artistic iceberg, indicating as it does the radical strangeness that lies beneath, such a strangeness as infuses not only the finest of Duras's own narratives, but her articles too, down to the challenges offered to her translators in their very register and syntax.

—*Dan Gunn, Paris, January 2019*

PUBLISHER'S NOTE

In selecting the pieces for this collection, our goal was to demonstrate the breadth and virtuosity of Duras's nonfiction (or near-fiction) and the originality of her vision even when applied to conventional prose forms (the newspaper article, the catalog introduction, and so on). Because we were less focused on presenting these pieces as historical documents, we decided against the use of footnotes (other than Duras's own). Instead, we have included a section of Notes & Context in the back of the book, which provides original publication citations for each piece as well as background information for those pieces that could benefit from additional context.

ME & OTHER WRITING

FLAUBERT IS...

Flaubert is one of the great writers. Period. When you voice a particular difficulty, by merely voicing it you come upon the solution. You first have to voice where the problem lies. There is always only one problem. You see a thousand problems because you haven't seen the particular problem of the solution upon which the thousand other problems depend. I had difficulty with *The Vice Consul*, for six months, it came to a complete halt. I've already said it, and I'll say it again, it's never the same. You have to say things again. I didn't know who was talking about the beggar in *The Vice Consul* and then I found out, the one who was talking about her was the writer, the one who approached the book like a reader, it was Charles Rossett. This is what I mean when I talk about a problem, not being able to find the right path through which to enter your own work. There are problems that are related to the text, how to "pass" the text to the other, the one who will follow you, the reader, how to make it intelligible for them. And then there are problems with the self. I think that when you live through a major event you immediately return to the mental confusion of childhood, and either

you make the most of this confusion and you write, or else you wait. There's no use waiting for a solution. The solution is already there but you can't see it.

Emotion is undoubtedly this return to the mental jumble of childhood. One might think we evolve out of childhood by developing defenses against aggression and flattening our reason, but this is merely a facade: the jumble represents the oceanic mass of our first hour, it's entirely of the same substance, the same force, the same danger. Everything is open. We are born with our minds open.

It's absolutely horrible to find yourself before a book you can't write. I was alone with myself. No one could help me.

There's no writing when there's no difficulty or else it's worthless, it's school kid writing, it's not writing. Sartre, de Beauvoir, and many others were in that phase that they confused with the "political" phase, the Marxist *simplification* of the social problems—economic and political—of the planet. To think about it is baffling, laughable.

For me the text of *The Truck* is not completely written, it's a spoken text. The texts that are completely written and that I can't even think to go beyond are *L'Amour, The Ravishing of Lol Stein, The Vice Consul, Aurélia Steiner, The Man Sitting in the Corridor,* and *The Atlantic Man,* and those to come if I live another two years.

I think I have always suffered in my life, suffered. I say this with no pretense—I had a completely screwed up life. And so I had fertile, abundant ground to write on. When I say suffering, here, I mean the ambiguous ground of happiness.

I've always written. I can't see the beginning, the moment when I started to write—I see the moments when I stopped writing sometimes, for example when I had a child. But the moment when I started to write is so diluted in my life, lost, no more memory of it, nothing. Men know nothing about that.

There are no books if there is no publication. I think that without the prostitution of publication, without the public act, there's no writing. I'll say it again, yes, because it's the number one problem of the world's intelligent minority. To be intelligent is to want to write.

It doesn't matter if you mess up a book. Some messed-up books are magnificent. *The Man Without Qualities* which I rank higher than all of Proust.

Writing, everywhere, among all peoples, still provokes horror. Where there is nothing, there is a piece of paper. It's the dawn of the world. There's nothing, it's blank. And then two hours later, it's full. You compete with God. You dare to create something. You write.

Going against creation, you write. You do your own thing. You. It's completely terrifying.

That fear you feel when you write, it's normal. You shouldn't fear that fear. If the fear didn't exist, you wouldn't write. When I reread my books, I feel fear. *The Ravishing*, *The Vice Consul*, *L'Amour*.

You have to trust this unknown, the self.

I said it in *Hiroshima mon amour*: it's not the scattering of desire or the romantic endeavor that counts. What counts is the hell of a unique love story. Nothing can replace it, not even a second love story. Not even a lie. Nothing. The more you provoke it, the more it escapes you. To love is to love someone. There is no other life to live. All first love stories are broken and then you carry that same story into other stories. When you've experienced love with someone you are forever marked by it and afterwards you carry this story from person to person. You can't separate from it.

You can't avoid uniqueness, fidelity, as if you were your very own cosmos. To love everyone as the Christians and others proclaim, what a joke. Such things are a lie. You can only ever love one person at a time. Never two at a time.

I've just spent a month making a film in a state of total distraction—a film for RAI, *The Rome Dialogue*—and the film is very beautiful. No. I think it's watchable, pleasant, but I come out of it with the feeling of not having written it. And yet I made it, I'm the one who made it. When I saw it I cried as if it weren't mine, as if all of a sudden it were leaving me and were being seen from a different viewpoint, as if by another self.

How can I say this without pretention: I have language at my disposal—I have to be careful. It's when I stopped working that I found it at my disposal. When I overworked my books I didn't have it at my disposal. It was with *Moderato Cantabile*, commissioned by Robbe-Grillet—twenty phone calls over the course of one year—that I started to write—how should I put this?—that I started to write nonsense in a given direction.

Work is always naïve, childish. Only laziness is noble, "great." Most of the novels that are rejected by editors are novels that are overwritten. Queneau used to say to me: Be wary of novels. A novel that is perfectly written, written to its fullest, should be avoided. Unless it stands alone in taking the plunge. Proust, yes. But a second Proust, as beautiful, of the same richness, would be rejected nowadays.

There is nothing more mysterious than this, the doubling of the human being through writing. To read is to write too. When another art form has existed for a very long time, the doubling does not necessarily occur in writing, in Egypt it occurred in art, architecture, painting, etc. This doubling continues in the same way today. We are no different from the Greeks, the Egyptians, those who lived in the Middle Ages, than we are from those who don't write. There are people who have always sculpted, painted, etc., and there are those who never will. Those who have never suffered the martyrdom of writing, I am forever cut off from them. Even if there is a mutual appreciation, the relationship between us will never be fundamental.

The most important experience you can have is to write. I have never had another experience so violent—except, yes, the birth of my child. In fact I can't discern a difference between the two. Writing is wholly equivalent to life. Sometimes it occurs outside of writing, sometimes it occurs inside of writing. In the things I have written most recently, I'm thinking of *The Atlantic Man, Aurélia Steiner*, it's inside, I don't see anything equivalent to it around me, outside of me.

The unknown in my life is my written life. I will die without knowing this unknown. How you write something, why, how I wrote, I

don't know, I don't know how it started. I can't explain it. Where do certain books come from? There is nothing on the page and then all of a sudden there are three hundred pages. Where does it come from? You have to let it happen when you write, you can't control yourself, you have to let go because you don't know everything about yourself. You don't know what you're capable of writing.

I've known some of the great writers, they could never talk about it—I knew Maurice Blanchot and Georges Bataille intimately, I knew Genet, but I'm less sure about him. They never knew, they never talked about it. I think that's wrong actually. Thirty years ago it was a kind of modesty taught to a certain extent in the Sartrean school of thought, you couldn't talk about what you were writing, it wasn't proper—and I think that *Woman to Woman* was the first time someone talked about it, one of the first times anyway. It's great to talk about it and at the same time it's very dangerous to have your books read before they're finished.

It's interesting, this difference between people who publish and people who write.

At the end of every book, it's like the end of the entire world, it's like that every time. And then, like life, it begins again.

When you write you cannot talk instead of write. We can never describe what happens when we write. I can read a passage but very quickly I'm horrified.

I'm more a writer than a living being, than someone who is alive. In my life I am more of a writer than someone who lives. That's how I see myself.

When I go to Germany the sounds of the voices in the streets, in the cafés, the shouts, I hear the shouts of the SS in the camps. I am forever lost to Germany. I cannot see myself there, cannot breathe. You should never go beyond what you can bear. Words cannot express my inability to tolerate Germany, this universal lineage, this echo, this death knell across all of Europe, how can we forget it?

Germany has birthed generations of people sick with Germany. I am one of them. Sometimes even now, when I wake up in the middle of the night, I give speeches to the Germans, even now, yes, because I think the Germans don't know what happened in Germany, of their own doing. What I think is that they have only been able to survive through their profound ignorance of what they did.

I did a long interview for the German radio station in Trouville at the end of the summer of 1980 about the fear of Germany. Still invincible. The young woman interviewing me was actually a

fake journalist. It was the two sound engineers who, all of a sudden, yelled out. She cried, she took the tape. It's a shame.

It's better that I exist like this than that I do not exist at all. Even for those people I make want to die, it's better that I exist. It's not a bad longing, the longing to die. It's not a disastrous longing.

I have no Catholic guilt. That people kill themselves because of my books won't stop me from writing. If people turned into reactionaries, political assholes after reading me, yes, that would stop me from writing, but not if they killed themselves.

What I write makes me want to die, it's only natural that it makes others want to die too.

Our experience also lies in what we read, in the intelligence of things.

Lola Valérie Stein is a queen. And I'm the proletariat. Only I'm the one doing the talking. Queens don't say a thing. It's the proletariat who write about the queens. I am the proletariat, completely. As for the vice consul, he's a kind of prince—a spiritual prince from another time, legendary, he's consumed by himself, he's completely overwhelmed. I'm the one who's able to write about him. When I write about him as I do about A.-M. S., about Ernesto, I firmly

believe in this predestination. I know nothing about L. V. S., about A.-M. S., or about the vice consul. But I must write about them.

When you finish a book you give it away. It enters the total unknown. You can't know the consequences of this language. You can't predict them. The book lasts the length of a book, except for some that have pursued me like *The Ravishing, L'Amour, The Vice Consul*. But now when I write books it's as if there were a journey, it makes me think of the journey of the dead in Ancient Egypt. You are forever separated from the dead, the book that as a consequence becomes life for others. But I can do absolutely nothing more for the book, I can no longer act, I am in complete mourning for the book.

The Atlantic Man is my last film, even if I continue to make films, *The Atlantic Man* will be my last film. After *The Atlantic Man* I will continue to make films but those films will not be my last films.

All of the world's filmmakers are beneath what I write for the cinema.

What I want is for a completed text be heard at the cinema. In *The Atlantic Man*, people watch the sound.

One of the greatest moments in cinema is when, in *India Song*, Delphine Seyrig dances with the young German attaché, she says

nothing and we hear her voice. D. Seyrig listens to her own voice, and thus to her own life. Cinema also happened elsewhere, in the dressing rooms of the actors when they listened to one another.

I am not yet worthy of what I've discovered in cinema. I'll be dead when people discover why it's so powerful. As long as I make films, as long as I live, I must remain unaware of it, I am unaware of it.

I am an unconditional fan of Mitterrand. I have complete trust in him, not as head of state, but as a person who suddenly finds himself to be head of state. Allende, Sadate, Mendès France, and Mitterrand are the only four heads of state that have mattered, the rest are garbage.

The suffering in the camps must be recorded, it cannot be forgotten, it's the memory of the dead. The crime against the Jews, seven million Jews, it's impossible to grasp, it's infinite, it's impossible to comprehend.

For five, seven years now we've stopped talking about the camps. Those who say that the camps are a recognized, assimilated phenomenon are the new anti-Semites.

I had Jewish friends who wore the yellow star and I myself did not wear it and it occurred to me that I could wear it too. I did not

understand why they wore it. They themselves did not know. We were oblivious together that it was to tally them up in order to deport them and gas them. Before such events, you always lack imagination. Even de Gaulle ignored the Jews, he spoke only of France. F. Mitterrand is the first to have spoken of France as an international space.

There is a fundamental intellectual infantilism in all peoples of the world when it comes to the Jews. I myself wonder how one can be Jewish today, how a Jew can accept having suffered through that. Other people say it happened. It's over.

It's not a question of personal culpability but of imagination. The fundamental evil, the crime, is that people cannot imagine being Jewish. I myself cannot imagine being Jewish: we cannot imagine it but we know it.

People who say that the Jewish problem is over, distanced from us, what a lack of imagination, what an enormous mistake: we must recognize that we cannot imagine it.

1982

THE SOUND AND THE SILENCE

Deep down he's a sort of child. Alto. Tall. White-skinned from Oran. One day they walked into the large auditorium of the Rond-Point during a rehearsal of *Savannah Bay*, Pierre Bergé and him. We hadn't heard a thing, neither the door nor their footsteps. Suddenly there they were, a few feet away from us, silent. Not wanting to disturb, always. Kings.

I know him very little, we've spoken two or three times, about theater costumes, colors, fabrics, about the panne of dark red velvet on one of Madeleine's dresses. Once he spoke to me about my books.

He intimidates. He intimidates more than anyone. More than doctors, more than actors. He is always the most intimidated of all. The most frightened. He comes straight at you. He brings toward you this naked face, blinded by fear. In his smile, as in his gaze, no sign whatsoever of power, nor of guile, nor of pretending.

We are overwhelmed by his presence. As if suddenly it were too much to handle at the same time, him and the presence of his body.

Yves Saint Laurent's gaze is indescribable. To start with, it contains an unbearable softness, sadness. Then in this same infinite state his gaze changes and fills with silence.

Yves Saint Laurent's gaze. He looks at what he sees. He sees with his eyes open. And he sees with his eyes closed. Like everyone else. And he sees all around him, and far away, and nearby, and below, like everyone else too. And see what happens.

That place where the man from Oran goes to work, his kingdom, he doesn't know what to call it.

I can't help but see, believe, that Yves Saint Laurent's real sleep happens when he is creating. Whether it is immediate, resplendent, accomplished, or whether it is still hidden, still lifeless, remote, it should always be about that, about creation, about what we also call the soul, genius. When I see Yves Saint Laurent in photographs or on television smiling, talking to celebrities, I think to myself, they've woken him up again.

I have always seen him as a writer. And as far from words as his work may seem, I have never been able to separate him from writing. He sees each person as the entire world and that's how writing enters his work. It's when intelligence is at the pinnacle of its power that it goes quiet. And that's when the writing flows.

All of life or its details, they are one and the same to Yves Saint Laurent, a single crowd, a single man, a single mob, a single des-

ert, a single being before him watching him, a single decor, a single whole, a single void. Like a writer he writes every day for the first time, I would swear it. It comes down to a single comma in the text, he knows: depending on a single comma, either the World exists, you've done it, or else it doesn't exist, you have to start over.

Let me come back to this again. He sees each of us as a part of everyone. He also sees the individual as lost, drowned in the droves. But, you'll say, that means each person sees both himself and the others. Yes, that's it.

He sees in you what you do not know you have. What you think you have he does not look at because you do not have it, you never had it. He unravels you. He restores you to your mortality. You do not feel a thing, you let him do it, you cannot do anything else because in his relationship to you, through that exchange he facilitates from you to you, you pass through a sacrificial moment. You and him, alone. You are in his hands, possessed. From this possession, you are reborn. You thought you were not beautiful. From this sorrow at not being beautiful, from this possession, you are reborn. From this sorrow he draws out your new beauty. You change eternities.

A woman. She's here. And he's here. He draws. And now the woman is dressed.

I'm inclined to believe that the legendary universality of Yves Saint Laurent stems from a religious tendency to welcome reality,

whether it is the one built by man, the one of the temples of the Nile, or whether it is the one man did not build, the one of the Telemark forest, the one of the depths of the oceans or of the apple trees in bloom. He, Yves Saint Laurent, does not mark a fundamental difference between what was built by men and what was built by the gods. Rather than classifying them, he brings them together, he gathers them. For example, a dress and a desert, he brings them together. He makes a dress, he puts a woman in this dress and he places the whole in the desert sands. Then there is an explosion of blinding obviousness, as if the desert had been waiting for the dress. As if this dress were in fact the dress the desert needed.

When an Yves Saint Laurent dress appears in a fashion show or on television, we cry out with joy, because the dress we had never imagined was the very dress we were waiting for, and on that very year. We are the desert awaiting the dress.

It's absolutely extraordinary to be recognized by the entire world, including by those who will never have access to Yves Saint Laurent's clothes. He makes what we were waiting for, every year. What I mean is that he makes what we did not know we were waiting for.

The price of a dress has nothing to do with the dress. The price of a painting has nothing to do with the painting. You will remember the theft of Monet's *Impression, Sunrise* a few years ago, this gaping

wound still open in our hearts. The elitism problem amplified by haute couture has been solved by ready-to-wear. The Saint Laurent women have left the harems, the castles, and even the suburbs, they flood the streets, the subway, the supermarkets, the stock markets.

It's as if the adoration others have for Yves Saint Laurent does not matter to him. He must think sometimes that he has nothing to do with it. What's more difficult to describe is the sort of self-neglect Yves Saint Laurent exists in. I would say there are people like him who are tempted by the loss of self, even more so by the massacre of this facet of the self that others call life, and that people like him don't call anything at all. There's not much more to say about it. We bring it up in order to say that it's inexpressible.

Let me return to his gaze. The gaze of one man, it's difficult to explain, the gaze of just one man in the world. He looks at a woman, a man, a garden, a photograph, a book, the sea. A prison. A photo of Auschwitz. A child. I don't think he analyzes anything, what I mean is that he doesn't comment on the things that are quasi-contemporary to him, and he doesn't even call what's evil, evil, and what's good, good. The details and the whole, for him, are the same thing. He takes the whole with the evil and the good or he takes nothing at all. I think he's right, even if he's not doing it intentionally, you have to take the whole, take it with you or leave it all there. Every

crime brings us back to all of humanity. But every smile too. You have to take the whole. Without that there is no writer, no Yves Saint Laurent.

It must begin with the path. That's the starting point. Through the night of the mind that point is a road. And it's a movement, the movement to take this road. To make this departure, this movement, you need one or two words, for example the word hip and the word sway. It's with these words that you start to wind your hips into the road, to wind the movement into the road. At a certain point it's done. The rest of the body will hardly be adorned. Everything will emerge from this winding of the hips. The pink winding, for example, may cause the rest of the body to be dressed in black. Or else a wild blue. Or a secret red called amaranth, brought from the Guianas like the flowers of the same name, or those men, Rimbaud, Mozart.

Similarly, sometimes I call Yves Saint Laurent by the name of another man. It happens in winter, at night, there's snow, and on the other side of a wall, across time, someone who can't sleep composes a song.

1988

MY MOTHER HAD . . .

My mother had green eyes. Black hair. Her name was Marie Augus-
tine Adeline Legrand. She was born a peasant, daughter of farm-
ers, near Dunkirk. She had one sister and seven brothers. She went
to teachers college, on a scholarship, and she taught in Dunkirk.
The day after an inspection, the inspector who had visited her class
asked for her hand in marriage. Love at first sight. They got married
and left for Indochina. Between 1900 and 1903. A sort of commit-
ment, adventure, a sort of desire too, not for fortune but for success.
They left like heroes, pioneers, they visited the schools in oxcarts,
they brought everything, quills, paper, ink. They had succumbed to
the posters of the era urging, as if they were soldiers: "Enlist."

She was beautiful, my mother, she was very charming. Many
men wanted her over the years, but as far as I know, nothing ever
happened outside of her marriages. She was brilliant, and had an
incredible way with words. I remember her being fought over at
parties. She was one-of-a-kind, very funny, often laughing, whole-
heartedly. She was not coquettish, all she did was wash herself, she
was always extremely clean. She had a sewing machine but she

didn't know what to have it make. I, too, until I was fourteen or fifteen, dressed like her in sack dresses. When I started to become interested in men, I picked out my outfits more carefully. Then my mother had me sew incredible dresses, with frills, that made me look like a lampshade. I wore it all.

I've written so much about my mother. I can say that I owe her everything. In my everyday life, I don't do anything that she didn't do. For example, my way of cooking, of preparing a navarin of lamb, blanquettes. My love of ingredients, she had too. I bore everyone at home with that. When there's no extra bottle of oil on hand, it's a problem. That's normal. What's abnormal is buying only one bottle of oil. What can you do with just one bottle of oil? What a disaster! What I've also inherited from my mother is fear, the fear of germs, along with the constant need to disinfect. This stems from my colonial childhood. Although my mother was very smart about practical things, she didn't concern herself at all with the domestic realm. As if it didn't exist. As if the house were a temporary thing, a waiting room. But the floors were washed every day. I don't think I've ever met anyone more clean than my mother.

When my father died, I was four years old, my two brothers seven and nine. My mother then became the father as well, the one who earns a living, the one who protects, against death, against illness—at the time, there was a fear of cholera. All three of us were crazy about our mother, and we must have made her happy.

She needed it, she showered us with an hysterical love, especially, even then, my older brother. Back then, she continued to teach for our benefit, and then, to increase her meager middle-of-nowhere teacher salary, she bought that notorious land with her twenty years of savings. Everyone's heard the story, her failure, her fury at having been duped. A failure that for me came to represent tragedy, much more so than a department store burning down. She nearly went insane. I remember the epileptic seizures that would rattle her until she lost consciousness. We were terrified to see her like that, we would scream our heads off. During that time, she no longer laughed, it was a disaster. We no longer had anything and the loan sharks were after us. We witnessed it all. I would think: "Is this really what life is?"

My mother, though she loved us, was never affectionate. I too am wary of affection. Never did we embrace in our house, never did we shake hands, never did we say hello. Never did we say happy new year, or happy birthday, that would have made us laugh. Maybe a little wave when one of us left, and even then! It was later that I realized I missed that. When I arrived in France, you had to kiss people on both cheeks, ask them how they were doing, that whole song and dance, I couldn't bring myself to do it.

What I wrote, my mother didn't like, not at all. She would tell me nonstop: "You, you were made for business. You must get into business." My mother, daughter of farmers, regretted all her life not getting into business. From the beginning, she understood nothing of my books. She was sort of illiterate when it came to literature. No doubt this profession she couldn't tolerate was the reason for our first separation. She only saw the side that wasn't serious, the literati, Parisian, journalistic side of writing. The tabloid side. Of course, she appreciated my success, the articles on my books. She had formed me in her image, I don't know if it was pride. Maybe I was her way of acting out a sort of revenge on life.

My mother had been a teacher first and foremost, and she was proud of me because I had been her student. A good student. I passed the exam for my school certificate at eleven years old, they had to make an exception for me. The teachers, at that time, were good at teaching spelling. I scored twenty out of twenty in dictation. The highest grade possible. It was a day of immense joy for my mother. Everyone wondered where I had come from. I remember, they pointed at the little girl, at the end of the bench, where did she come from? She came from the middle of nowhere. Where, for four years, I had spoken nothing but Vietnamese. I was afraid. It was in

Saigon. The exam took place in a big empty middle school. It was the first time I had seen so many white people. My mother took it hard that my brothers couldn't pass the exam. They couldn't do anything, school didn't interest them, they dropped out at around ten years old. Then my mother bankrupted herself on correspondence courses for them, the Universal School, the Violet School for my older brother. They only lasted two days.

She took teaching very seriously. My mother and the other teachers, they're the ones who brought French culture to Vietnam. A hundred thousand students must have passed through her classroom. She was much beloved, no doubt also because of her great generosity. She couldn't stand for a student not to go to school because they were too poor to buy the supplies. At that time we lived in a magnificent house with a tiled floor. She would lay down mats all over for the young girls who lived too far from school, and she would feed them at night. It came naturally to her. That's why I'm still a little reticent when people talk to me about certain aspects of colonialism. The teachers were truly passionate public servants, who killed themselves working and who had miserable salaries, the most miserable of all, the same salaries as customs officials, postal workers. My mother, when she bought her land, had no idea about the dirty bribes and under-the-table dealings. I think it's because of

my mother that I've retained a sense of honesty. I thought to myself the other day: "I am honest, painfully so, like my mother was."

I wasn't really aware of it and I didn't care when my mother would tell me that I was her best student. I was simply interested in my studies. What really had an impact on me was when someone other than my mother told me that I was a good student. She would have done anything for me to be a math professor. So I enrolled in Advanced Mathematics. Halfway through the year I dropped out.

I admire that after her failure with the land my mother did not give up. She had retired from teaching, but she went back to it by creating the French School that was soon full of Indochinese and French students. The classes she taught there were so straightforward that all the kids understood, even those who had been worthless in other schools. Word got around to the families and her school was soon jam packed. She knew how to *manage* her staff, with that incredible authority she always had over people.

Although she was a teacher, my mother didn't read. She never read anything. She didn't buy us books. The only books I read, as a child, were the books that she had to give away as prizes: Victor Hugo, whose *Les Misérables* I read two or three times, in comic book format, illustrated by Gustave Doré. I remember a book by a woman about Indochina, Christiane Fournier. One by Pierre Loti also, oth-

ers by Delly, Roland Dorgelès, and a novel, *The Bachelor Girl* by Victor Margueritte. Only textbooks were worth something to my mother, who didn't like when I read. She would yell, she would say that if we were reading then we weren't working. I remember that even so she still had me read certain things by Michelet, the type of writer that suited her. She used to say: one of the greatest writers of all time. Which I've always agreed with. And also Renan. Right now I'm rereading his history of Christianity, *The Life of Jesus*, one of François Mitterrand's favorite books, if I remember correctly. And also the books about Joan of Arc.

I find that in literature, no writer's mother compares to mine. My mother, she was a great character, a comical character, too. She had all the attributes of a great character. She was capable of madness, like the affair with her land, but she also possessed a great lucidity. She embodied those contradictions that make for great characters, like when she nearly died upon learning that I enrolled in the Communist Party. But she is not the main hero of my body of work, nor the most permanent. No, I am the most permanent. Writing is to write for oneself.

I believe that I loved my mother more than anything, and that it came undone all at once. I think it happened when I had my child.

Or else during the film based on *The Sea Wall*. She didn't want to see me anymore then. Finally, she let me back into her home, saying to me: "You should have waited for me to die." I didn't understand, writing it off as a whim, but it wasn't at all. In what we believed to be her glory, she saw only her failure. That created a rupture and I didn't make any effort to get closer to her again because, from then on, I no longer saw any possible understanding between us. Other disagreements followed. And then didn't she also have that excessive preference for my older brother? I've spoken about it so much. She loved her eldest son the way one loves a boyfriend, a man, because he was tall, handsome, virile, a Valentino, while my little brother and I were like fleas next to him.

I think one of my mother's problems is that she never had any love affairs with men. I have the feeling that she was completely ignorant of what it could have been like. People told me that my father was very much in love with her. And that she wasn't with him. I wish her *preference* for my brother could have been bearable. But it became unbearable, especially when, egged on by him, she would beat me. He would watch her and say: "Harder!" He would hand her scraps of wood, broom handles. She really roughed me up, yes, she would hurl herself at me when I slept around. She didn't slap me, she kicked me and hit me with a stick, with the help of my brother. One day things became clear for me, but too late.

We didn't confide in my mother. Yes, when I was little, I told her everything, I stopped with that Chinese lover. My brother told me that I was acting like a stranger. She was always oblivious of that whole part of my life. For example, she never knew that when I was twenty, in France, I was forced to have an abortion: the guy was very rich, I wasn't yet an adult, his parents didn't want there to be any trouble, they drew up fake certificates, they wrote on them: appendicitis.

Today, my mother, I don't love her anymore. When I talk about her, like I'm doing now, I get emotional. But maybe it's me faced with her, my reflection, that makes me emotional.

At the end of her life, she was as detached from me as I was from her. Fortunately, she had her son. She lived in Touraine. I only went to see her in order to feed her, because she said that no one cooked meat like I did. I would drive for six hours to cook her a steak. She thought only of her son. She was always in a state of constant worry for him. I don't know how she lived like that. Today, she is buried with him. There were only two places in the family plot. It would have been impossible for all that not to have degraded the love I had for her.

If I express care, emotion, when I talk about her, it's because I think about the injustice she suffered as well as the injustice she

perpetrated. The image I have of her is not a very good image, is not a very clear image. I see her again preventing me from kissing her, pushing me away with her hand: "Leave me alone…" I still write about her, she's still here. But, for example, today, I find my father much more beautiful than her. On my walls, I have tons of photos of my parents. In this one here, look at how carefree my little brother is, and how my older brother already has that controlling, knowing smile. I have separated myself from them in life. We separate ourselves from people by writing. But now with death approaching, that woman seems much less harmful to me than before.

Back then, I saw with a real joy, like an unexpected revenge, my brother and my mother screaming at each other for stealing the money that I brought home. Money that I was given from the boys in those private lessons I took who were more or less in love with me. And when I wanted to pay for the burial of my brother's mistress, my mother succeeded in taking the money for herself. Today, I tell myself I don't have any right to reproach her for those things. I accept that she loved two of her children less, but when I see similar situations around me, I think to myself, okay, it happens, but it always makes me very afraid for the child loved less.

I wrote that my mother represented madness. Doesn't every child think of their mother as a sort of lunatic? Don't we often hear: "My mother is a lunatic, a madwoman"? That doesn't preclude love. I myself am a mother. Am I crazy? I don't know, but I have raised my

son very poorly. I had lost a child before him, at birth, and he suf-
fered for it. I spoiled him too much. I was afraid all the time. In the
end, I think motherhood makes you obscene. A mother indulges
in all of her games. I remember my mother playing war in front of
us, singing "The Regiment of Sambre and Meuse." She would hold
a stick like a shotgun and she would sing, then she would cry, cry,
thinking about her brothers who died in Verdun. We would cry too.
Then after we would say: "Whatever, she's crazy."

1988

ATLANTIC BLACK

I've just made two films: *Agatha* and *The Atlantic Man*. The first is 90 minutes and the second 42 minutes. *The Atlantic Man* is partly composed of unused *Agatha* takes. Now there is nothing left from the *Agatha* shoot, just a few seconds of footage, a few "action" and "cut" shots, and two random takes, one of the camera facing a mirror in the hall and one, very beautiful, of a path lined with trees, elms, crossing the fields that border the sea. This path should have been taken by the young girl and the child the night before their separation, had that scene from *Summer 80* been shot.

Now I have nothing left, neither before nor behind me, nothing lingering, nothing to envisage, nothing but the color-black. We're going to throw out the new film stock, the one blending *Agatha* and *The Atlantic Man*. I am going to forever leave behind these two films.

Something significant took place with *The Atlantic Man*. I didn't have enough film stock from *Agatha* to fill it with images. And I didn't want to fill it with images that had been shot for that reason,

for the film, to swell it with images. I wanted to keep it as is, inadequate, inside the hall, which is to say inside love, to not purposely do anything that would allow it the comfort of representation. So I made use of black, a lot of it. I wanted this black as-is because from the beginning I knew I didn't have enough images to cover *The Atlantic Man*. And in discovering this shortage, I discovered the full use of the text I had written for this film. So much so that I wrote even more, and more, and more and more freely, further and further. After ten minutes of black, that was it, it was now inconceivable to find an image to go with the text. Finding matches proved to be futile, truly unobtainable, drowned in the invincible current of the black. I now believe that the black film roll kept all hands from dividing it, stopping it, slicing it.

This is my first time shooting color-black, what I mean is this is my first time writing entire texts over color-black. The *black and white* image is more dazzling than *the black of black and white*. The *color-black*, conversely, is more vast, more profound than the *color image*. We watch it more closely. It flows all at once like a river. It's not a stationary material, but a material in movement, identifiable among the rest because of its closer relation to sound, to speech, as long as no image corrupts the integrity of the relation between black and sound, and above all between black and speech, between black and life, black and death.

Black can be scratched, damaged, like an image. What it has, unlike an image, is the power to reflect the shadows passing in front of it, like water, a window. What we see emerge sometimes on the black are glimmers, shapes, people passing through the booth, machines that have been forgotten in the windows of the booth, and unidentifiable shapes, purely ocular, a result of the vastness of the break the eyes experience during the black, or, on the contrary, the horror certain people feel when they are told to look without being told what object to see. None of this can be captured by color. Streams, lakes, oceans possess the power of black images. They flow.

There were several of us in the editing room and we never felt the lack of images. We always watched the screen on the table, just as later we watched the screen in the projection room before the sound mix. I have to say that I'm realizing this only now, and not while the film was being made, so obvious was it then.

I think black is in all my films, buried, beneath the image. All I have ever tried to do with them is reach the deep flow of the film, once free of the image's permanence. Black is in *The Woman of the Ganges*, in *India Song*, in *Son Nom de Vénise dans Calcutta Désert*, in *Le Navire Night*, in *Yellow the Sun*, in the Aurélia Steiner films. It is not in *Baxter, Vera Baxter*. It is also in all of my books. I have called this black "the inner shadow," the *historical* shadow of every individual. I will use this again to name the forever brilliant

"magma" that "makes" every living person, without exception, in every society, and in every time period. I think what I seek through my films is what I sought through my books. In the end, it's only a diversion and nothing more, I haven't changed jobs. The differences are very small, never decisive.

I can film, it seems to me, more easily than I can write. For a film, I can always write, it's true, always. For a book, no. A book that remains to be filled always terrifies me, will always terrify me. The film, no. And yet, when I watch my films, I find them just as written as my books—but the texts are shorter. Between *The Ravishing of Lol Stein* and *India Song* there is far less text, fewer months spent writing.

Before a text, there is the naked wall of the book, the insurmountable, invisible boundary of reading. It's the black of the book, always there, with each line, with each word. The film is open, public, you can see how it's made, how it's viewed, you are under the illusion that you are witnessing the verification of its creation.

I was always embarrassed to attend the screenings of my films, wherever they happened, under any circumstances. But this embarrassment was always more violent when it came to my books. One day, on the Café de Flore patio, a few years ago, I realized that a young girl a few tables over was reading *The Ravishing of Lol Stein*. She hadn't seen me. I made off like a thief. My memory of that moment is of the great danger incurred by me, the author of the book.

The risk in this case being to *show* the person who was reading Lol V. Stein the face of the woman who had written L.V.S., to act as if Lol V. Stein had an author.

With a text, one must reveal to the outside what should naturally remain intrinsically bound to a person and accompany them into death. Writing is abducted from death. Death is mutilated with each poem that is written, read, with each book. Film is a secondary phenomenon.

1981

LETTER TO CENTRE RACHI

When I accept invitations to conferences, I always do so thinking I'll be able to attend. But when the time comes, I literally cannot move. It can't be helped, as you know. It happens to everyone, but I know it happens to me and I accept the invitations anyway. I take responsibility and I apologize.

I am obliged to tell you this as well: my inability to come to the Centre Rachi was also in part due to the fear that someone might ask me questions about the characters of my books: why they are almost always Jewish. I would not have answered. For me to answer, I would have to do something that I don't want to do, I would have to hone in on this trope of mine—the Jewish characters—and then speak to the widespread presence of this trope in my work and in that of other authors. But I would never have done that either. The idea is unbearable to me. I don't know for certain why the people in my books are Jewish. But the idea that someone might tell me why is intolerable.

I can write about the Jews in stories, in novels, in films. But the Jews in my novels, in my films, they keep silent like me. We keep

silent together and that makes the book. They call us Jewish, the Jews, they say: "She, she's with the Jews, so you see, you can't believe what she writes, she has other motives."

In my life—I said it recently on English television—first there was childhood, then adolescence, in full clarity. And then suddenly, without warning, like lightning, the Jews. No adulthood: the massacred Jews. 1944.

I'm sixteen years old. And then much later I awake from being sixteen. And it's Auschwitz.

What happened to me in between, the war, the children, love, everything fades. The Jews remain. Which I cannot speak about.

Love to all.

1985

TRANSLATION

The invitation to ATLAS in Arles, in November 1987, was the only invitation I had accepted in years. I couldn't attend. I was admitted to the hospital October 17 and was released last week. I am still much too tired to make the trip and participate in workshops even if I am not obligated to actively take part.

I would like to use this opportunity to share with you one or two thoughts I have on the subject of translating a text. I have always believed and I believe even more so now that a text translated into a given language becomes a text within that language. Always, in every instance. I believe that when a text is translated, secret data about the text's new allegiance emerges. For me, *L'Amant* is also an English book, a Swedish book, German, Turkish, etc. A book is never simply translated, it is transported into another language.

There was a time in my youth as I was finishing my studies when I could only read translated books. I never had any desire to read foreign novels, especially those that I loved quite a bit, in their original language. One language can never be juxtaposed against another language, not in my opinion: we cannot juxtapose the an-

gles of words, their length, etc., or their meaning. Everyone knows that translation is not a matter of the literal exactitude of a text, but perhaps we must go even further: and say that it is more of a musical approach, rigorously personal and even, if necessary, deviant.

It's very difficult to say. That's sort of what I wanted to do, try to say it: *musical errors are the most serious errors.*

A translated text has been translated by someone based on a first reading which is always just as personal as the writing, and which can never be erased. Is it possible to talk about a musical translation? We talk about musical interpretations. It's a shame that when we talk about translation, we stop at its literal meaning. As if meaning could only be found in texts, and not in music. Doesn't the convention of respected meaning in fact propagate backwards ideas that work against the liberty of a text, against its breath, or its madness?

1987

I THOUGHT OFTEN . . .

I thought often about the differences in education, climate, geography between people, people and the youth. I thought about the difference between being born in Indochina, or in Flanders, born either to a teacher at an indigenous school who was shaped by the existence of injustice but very far removed from centers of knowledge, or born to a wealthy man with no heart, bound to his riches. I believed in these differences, I never thought about any other differences than these. I no longer believe in anything.

Not much is being offered to the new generations other than pure intelligence, without epochal structures or circumstantial support. No longer weighed down by anything, not morality, not politics, they feel abandoned and choose fictional social and economic pessimism, or sports, or a literature void of genius that claims to be scandalous. But the majority steers clear of intelligence. It's a frightening continent, burnt, offering nothing, with no knowledge. Here nothing serves a purpose. There is nothing to learn, to see. Every causality vanishes. Every reciprocity. Either one is intelligent on the threshold of intelligibility or one is not.

I believe that when I was 25 I was an old woman. I read the Bible, Marx, some Kierkegaard, Pascal, Spinoza, not Hegel, not Sartre. I was there, conscientious, I wanted to learn, I believed you could learn, I used the words of experience, of life. I believed you could learn from older people, from nature, from the things you knew, the things you read.

Through the Bible I unlearned everything. So much time is wasted. I no longer believe anything. You read a book, you become a book, there is no subjective relationship between you and the author you're reading. You read *The Ravishing of Lol Stein*, you become Lol Stein, you are her but you have nothing to do with me. I have nothing to do with it, it's completely finished. I did it. The name still exists, that's all. I will die with the unknown: who is writing. I will die with writing. Writing does not for one second help me live. What helps you to live is the moment itself, abrupt, elusive. No other concept. None. Very fleeting, immediate plans. If in a hundred years *The Ravishing* is still a classic, it's none of my business. It's incredible, people think that "making things that will outlive you" will help you live. What sublime naïveté. The absolute, terrifying need to perpetrate life. The despair of all of humanity. For good *reason*. But whose fault is it that life generates death? It's so abominable that people have invented gods, poems, suicide. But we can also live better knowing that these are all ploys.

As if the possibility of people reading *The Ravishing* in 2050 can make death any better. The only remedy against death is suicide.

The problem—I've said it before, I'm beginning to say it again—is figuring out how to occupy the time you're alive. It's better to occupy it than not to occupy it, as sometimes it can be so captivating that you forget death, this narrow margin, this river, this trickle of water. Life is restricted to life. How can we convince ourselves? It's better to do what I do, write, than not to, it's better to do that than to do nothing. If you can do otherwise, for example, nothing, perhaps it's better to do nothing. But don't think that the importance of what you do can change death's timeline. The sense of death that every being carries within them, throughout their lives, cows, horses, men, imbeciles, geniuses, the absolute fear of what is absolutely unacceptable, the absolute disappearance of life. Why this fear, this terror around death? Now it's in fashion to be in denial about death. To go against the education humanity has gained. Non-death. Among the disabled at Hiroshima there was a man who didn't sleep, for two years he didn't sleep, finally died of not sleeping but not for two years, he wasn't anyone anymore, he looked at his children who came to visit him and no longer knew them at all. His heart was still beating and from time to time his eyes would open. He no longer moved at all. He no longer spoke at all. He had gained a lot of weight, he had become a mass of jelly animated solely by

the intermittent batting of his eyelids. They knew he wasn't sleeping because of the batting of the eyes. Of all the tragedies of Hiroshima this is the one I think about most often, this man who hadn't slept in two years. It was the only case of its kind in Hiroshima. It was never explained. I was never able to imagine this torment.

Women have a real wildness in them, men are the victims of influential thinkers, they are plagiarists of learned behaviors, sexual, intellectual, social, etc. Now that women go into the forest, they are infinitely freer than men.

Men are feminine like women were in 1910 whereas we, women, are feminine like in 1981. Men follow, women begin. All of men's arguments are learned arguments, whereas women use arguments they invent.

It's impossible for a man and a woman to have a discussion. Men are tired, they're a bit sick, a bit suicidal, they don't possess any real curiosity, they possess a certain guilt. The future is female. I say that with a little sadness because I would like for the future to be both genders, but I believe it's female. Men are sick with that sickness, masculinity, always and forever.

I love men, I love only them.

We must do away with the bias of representation. If you show a scene you may as well show how it's filmed, how a camera films the scene. That is just as much a part of film as the scene being filmed

by the camera. Showing the public how film is made is film. Not showing the camera, the material elements of production, that's like not showing the money, the billionaire train all film rides on. The markets of film, petroleum, gold, and weapons are wholly equivalent. I show the camera. I show how a film is made. It's clear that this is an attempt to put film to death, that perhaps without wanting to, that's what I'm doing.

In the middle of a film, often, I don't believe it anymore, I break it, I can't resist what I call murder. I think all the filmmakers of the world profoundly disgust me. I like only my films. I think filmmakers who make a film with billions don't sign their films. I'm sure I sign all of my films, like I sign all of my books. If something is signed, it's my work.

The directors, the makers of films are for me part of the proletariat, slave laborers, paupers. They are in a parallel state of alienation. True freedom lies in this illusion of doing what you want and believing that you're disregarding its outcome.

There are people who don't feel the need to talk, to answer, to know, to see, they are there, living all the same, for no other reason than the confinement of a heart in a rib cage, a nervous system spread out according to the admirable common reference point. I can absolutely accept that, but they should refrain from making films that plagiarize American films to such a degree, there's no need for that.

I feel that there's an enormous amount of energy being exerted so that people don't change, so that the people of the world's outsized populations stay the same, exactly where they are, in the state of this sole knowledge, that they already belong to undesirable demographics.

There is a tragic and delirious attempt by everyone to identify with everyone else. Identification that goes from loving you, you, to dying of love for everyone. People want to die of loving you as much as they want to identify with those who will never love you. They want to destroy themselves with love, love being an end in and of itself, they want to die of the same death, thus die of the same love, thus reach this impossible, intolerable identification that none of the world accepts, that of incest. I believe absolutely in this starting point, for all.

Inanity is infinity: it's completely parallel, it's the same word. Life is complete inanity, it's infinity, and so long as it has to be lived and is unlivable, we seek palliatives for this inanity. It's not because God doesn't exist that people should kill themselves. Because the statement "God doesn't exist" makes no sense. Nothing will replace the inexistence of God. His absence is irreplaceable and magnificent, fundamental, brilliant. Let us be cheerful, in joyful despair because of this word, God. It's hard to accept but I think it's clear.

The woman in *The Lorry*, is, day in and day out, joyous to be without God, without a plan, with no reference point of any kind, always happy to see, to see the day, the night, to meet truck drivers and the shady guys from the P.C.F. or the C.G.T.

Joyful despair is not a reason to live, it's a reason not to kill yourself—to kill yourself is naïve, it's mental indigence. Life is there, within you, why not take it, it's there and you're equipped, why not take the time offered in life, it's there, it's given even if it's also simply mysterious, why refuse this unsolvable provocation. To refuse life is to believe it. You can't leave life, it's survival, there's no other way of living it. Suicide is utterly idiotic, it attributes meaning to life but no, there's nothing but life. Everyone has the means to exit life, to kill themselves, but every democracy has its naïveté, its indigence, even this democracy. There is no solution to life, only to live it.

The laughter of children, their cheerfulness, their hysterical laughter, that's the only true requirement, it would seem.

The most naïve of all has to be Sartre. All theoretical thought is abusive. And as I'm saying this, it's completely true for me. One should only write literally about reality: it's 9 o'clock at night, end of June, it's hot, through the high hedges the yellow light of the evening and I'm writing these absurdities.

I've never gotten over the despair of politics. It's through this naïveté that I became a writer. For Sartre and the others, there was too little activism, you had to get there by teaching. To spread an idea, that's what works best because people are hungry for justifications. That's what naïveté is. Happiness is being aware of the fundamental dissatisfaction we exist in and also its unsolvability. It's a non-problem. It was perhaps necessary for the French Revolution, to rouse the masses, but it's still an example of fundamental naïveté. Still, it's this false speech that did the greatest harm to that system, Marxism. If Marxism is over it's because of that idea and its fate starting with the French Revolution all the way to 1917, namely the concept of the people's happiness. Happiness for all never means the happiness of each person and the happiness of each person never means happiness for all. Happiness is an individualistic, individual concept for the individual, and nothing can in any case, with respect to society, take its place. Society cannot determine happiness. If I derive happiness from stealing or killing, it's not because society has dictated it to me. Essential stupidity must lie within that Marxist morality.

Happiness is a concept with tragic ties to the individual, it's not handed out by society. Happiness is now a regressive concept, it's sociological foolishness but no doubt indispensable.

As for me, what restores me to the freshness of existence—which I hope will stop only with my death—is that man has invented God, and music, and writing. It's not the Crusades or Marx or the Revo-

lution, rather it's all of Rimbaud's poems, all of Beethoven, all of Mozart, all of Bach, and myself. I believe that the Revolution did some damage to man, to the history of the thought of man. I believe that what I believed in and what I subscribed to for years, this Marxism-Leninism, is profound nonsense—in the serious sense of the term—as one would say: profound intelligence. What we are looking to get rid of now is still and always Marxism, which leaves no voice free to be fresh, to improvise, to be a voice for women, for children, for lunatics, etc. Everything is absolutely cemented by Marxism. It's a sickness.

There is no happiness other than that of intelligence. I think people like Rousseau, Montaigne, Diderot all attained it.

I have spoken a lot about maternal love because it is the only love I know to be unconditional. It is the love that never ceases, sheltered from every storm. It can't be helped, it's a calamity, the only one in the world, marvelous.

I have been living on my own for over ten years and it is the most generous life I have ever had.

1981

HORROR AT CHOISY-LE-ROI

"Beware, beware! There's been a lot of writing on this crime 'without a name, without a motive,' published in order to intimidate us. Let's ignore the complaints of those aesthetes who want to protect the category of 'crimes of love' . . ." (*L'Aurore*, June 4)

We sought explanations linked to fraud for the crime of Simone Deschamps and Doctor Evenou, combed through their bank accounts, their marriage contracts—which revealed nothing. We sought passionate explanations—Evenou seeking to rid himself of his wife—which also proved to be false. No doubt we'll keep searching, trying to find typical motives, trying to "align" this act with what most satisfies our reasoning, which is uneasy outside of neat categories of crime.

It will be difficult, but no doubt we'll manage it and, we hope, all while avoiding the pitfalls of the hypocritical machine that generally reports the news.

We can't explain darkness, of course, but we can still define it, leave in the darkness that which returns to it.

Even if Evenou had a true "passion" for Simone Deschamps, we

don't believe—it's still a burning question—that he actually loved her. This is no doubt about something else entirely. About an eroticism that, like love, could be defined by its bipolarity but then taken to its apogee, seen through to its end. I love you so I hate you, so I'll kill you. Even though his sex life with her was unparalleled up until that point in his life, never, he said it himself, would he have married her. He wanted her to remain a clandestine part of his life, in other words for her to remain shameful, like the perfect vice. But the affair was already seven years strong. And, as its clandestinity was slowly coming to an end, she desired more and more imperatively for this affair to have a future, a consequence. No doubt, here we can glimpse the hell to come.

Make no mistake. That woman who, last Friday night, that ugly, old woman, in the ostentatious dress of eroticism, naked under a black coat, wearing black gloves and armed with a knife, as she carried out the crime, played out the final act of her love. She loved him. To the extent that she conformed herself, and even her love, to the form and the destiny that he desired. While it's very difficult to distill a news story from its emotional context, we are still tempted to do it. The performance of this crime stupefies, and it stupefies because of its clear meaning. Evenou gives his mistress the illusion of freedom. But she herself is not duped. She will wait for the telephone call, will ascend alone, at midnight, the three floors that separate her from her crime and his death. And there she will wait for him *as if she could turn back*, as if she were free to stop loving him or

go on loving him. She then goes to commit the crime, an atrocious crime, barbaric, as a young woman goes on her first date. For just as their passion ends, she experiences the ultimate rejuvenation. He made her dress up like a Gilda—but for one man alone—parody a final strip-tease—he had known her for seven years—beyond which neither of them could go anymore. And after he had embraced her, after he had said goodbye, he showed her the way to her crime, the location of his heart, once more, *as if she didn't already know.*

Of course, there was premeditation. Perhaps even for the last seven years. But no doubt that term is inaccurate when the sexual imperative reaches such a degree, its outcome, which is to say its suppression. Once again, even if she loved him, she acted as though she did not love him—in accordance with his desire—love overturned in the face of that sexual need. And again she acted in accordance with his desire by "freely" poisoning herself with this sentiment for a month. And while he, perfect parody of a deity, awaits her in his wife's bedroom, she acts exactly as though he were presiding over her destiny, she plays the slave, she plays the subject of this horrible, secondhand God—who does not scare her, however—until the very end.

I think we have to accept the "truth" of the darkness.[1] I think

1 I remember reading a letter from a sadist criminal, who is well known in fact, from the beginning of the century. The letter continued normally until the moment when the criminal arrived at the precise moment of the murder. Suddenly, he started using extraordinary, unintelligible language, made up of onomatopoeia, but perfectly penned. It was like suddenly entering into that "truth" of the darkness that I posit here.

we have to kill (since we're in the habit of killing) the criminals of Choisy, that once and for all we need to renounce understanding this darkness from which they emerge because we cannot know it in the light of day. The newspapers are naïve in their mistake: "Slipping from the stage of love games into the extreme depths of crime," what does that mean? This is a voluntary omission of the intermediate stage, which is crucial, which leads us here: when the games stop being games, are no longer entertaining, but mortgage the conscience until it's eradicated entirely.

No doubt we're in a world where the game, in all its forms, is reassuring. There are highs, lows, we win, we lose, it satiates our passion rather freely, it finds release in itself. Typically we risk playing it over and over, the same game, in a simple and predictable way, with no surprises. The vice itself, in general, that fixed, definitive form of the game, entertains us more. The monsieur from Dijon who goes each Saturday, like a civil servant, to Paris to engage in a sexual game that's performed perfectly, and who returns Monday to see to his business in Dijon, doesn't frighten us anymore. His story resonates with us, like something we learned at school. He has discovered in himself a very particular sexual preference (we don't blame him, we absolutely refuse to condemn existing "forms of sexuality") and he is as invested in it as he is in his familial and social standing. But here, in his hellish search for that preference, the world is suddenly turned upside down. Everything disorients us. Including the ugliness of Simone Deschamps. Because she was

ugly, we can't understand it. But now we learn that Evenou knew, knew that she was ugly. He went so far as to denounce her ugliness in public, tactlessly. He made fun of her. And she accepted that she was ugly and that he made fun of her for it. Just as she accepted that he mocked her love for him, abominably, in public. For she knew that he had suffered the stranglehold of that ugliness, that it had become irreplaceable for him. And she herself endured, as if it were coming from God, fatally, his vile tactlessness toward her . . .

Sometimes we abandon our conscience rather than taking refuge in the hypocrisy of today's accepted morality.

"Why were you naked under your coat? With boots and black gloves?"

"It was the doctor's orders, Your Honor."

"Why weren't you in *normal clothes*?"

A burst of laughter in the courtroom. For good reason. The *normal clothes* Simon Deschamps should have been wearing to carry out her crime are not identified.

"It was," explains Judge Bonhoure, "because you were a monstrous sexual pervert and you were seeking extraordinary sensations."

"No, Your Honor, I have never sought extraordinary sensations."

She is reminded of the particular nature of her sexual relations with Evenou, their "decadent acts," how she prostituted herself with North Africans, while Evenou watched, how she flagellated herself.

"Yes, Your Honor," responds Simone Deschamps. "That is correct, Your Honor," she responds again.

"Witnesses will come tomorrow to confirm that they partici-
pated in those acts," the Judge threatens.

She doesn't respond. They continue. The prosecuting attorney
and the judge assume the tone of severe censors with her. They
scold her. She looks like she's been scolded. Great foolishness hangs
over the room, we all take part in it. No doubt we grow accustomed
to such foolishness over time. It was new to me, suffocating, to the
point that I felt faint.

"One time . . . naked . . . with two women . . . Evenou was there
. . . witnesses said that you enjoyed yourself quite a bit."

"Not at all, Your Honor."

"So, what was in it for you then, in these acts?"

"I loved him, Your Honor."

What do these men want? I mean those in the court system.
If Simone Deschamps were to writhe around on the floor in the
grips of remorse, it still would not be enough. She acknowledges
nearly everything that they reproach her for, all the evidence. She
acknowledges giving herself over to the most perverse acts. But they
want her to acknowledge having enjoyed it. She denies it. And that
leads to her being reprimanded. Very severely. So she lowers her
head and she stops responding. And it might be in those moments
that her power of servility, unbeknownst to us, emerges. It's when
she says "It was the doctor's orders" that we are afraid. But they'll
tell her that "there are orders one does not execute." She'll make a

hand gesture signifying that the judge is quite right to make that judicious remark. But that you see, and *this is the problem*, there are people, including her, who are passionate about execution.

"I can't explain myself . . ."

What I would like to be able to convey is the psychological state of the accused faced with—in particular—the packed room on Tuesday afternoon. It's an entirely functional situation that brings to mind what it must have been like for Simone Deschamps faced with Doctor Evenou. Simone Deschamps has nothing more to say because the judicial system forces her to tell us in its own language. So she too will speak of the "atrocity" of her act. She will harness specific aspects of the judge's moral viewpoint to evaluate her own acts. And when at the end of the trial, yesterday, she cried—very low: "Leave me alone!" it's because she had reached the end of her silence.

I believe it was the plaintiff's lawyer who said that it was a rather simple defense. When it wasn't a defense at all. In the same way, when she acknowledged twice her inability to speak about herself—"I would like to be able to explain myself but I simply can't"—no one insisted that she do it. I didn't know that the speech of accused persons was so violently cut off. They can only speak when interrogated. And as soon as they get up to speak, they are not given the time to do so. Clearly the last person who matters

in this trial is Simone Deschamps. Her existence, even her youth, will henceforth be defined entirely by the abomination of her act. The efforts of the entire judicial system consist in finding in her youth the "signs" of her future darkness. I apologize for not being used to the court system. But it's stupefying. The witnesses who will come to say positive things about Simone Deschamps will never be thanked for their deposition. Some of them will be scolded, reprimanded, because, even provoked, they still will not condemn the Simone Deschamps that they knew.

"She would wait for him from four to nine in the evening," a female restaurant owner from Choisy will say. "He would humiliate her. She never stood up to him. I felt bad for her. He was more than a nympho, he was a madman. And an actor, first and foremost. And repugnant, etc."

The judge will try to make this woman say that he was only like that because he had met Simone Deschamps. She will say that she's not sure, will insist on her ignorance. And will be reprimanded.

"I'll explain nothing," Simone Deschamps said Monday night.

And today, when the judge told her that the time had come for her to "apologize," she said:

"I can't speak anymore."

It's true. She "can't" speak anymore. These words are not meant to be taken viciously. I am merely expressing regret. We are the ones who suffer from this injustice. There is injustice, for us, when

a criminal—even one like Simone Deschamps—can't manage, can't even manage anymore to tell us what she knows about herself, as is the case here. It's striking. Children must not speak at the table. Reduced to an imperative, imperious infantilism, Simone Deschamps falls quiet. Not only does she not interest anyone anymore, but she is no longer interested in herself. She is no longer anyone. She listens with a vague curiosity to the witness testimony recounting her past to her. But what she fears, above all, is being reprimanded by the judge and the plaintiff's lawyer. Would she prefer prison? It's possible. I have no opinion on guilt in general or on that of Simone Deschamps in particular. Especially when she finds herself so betrayed by the judicial proceedings that she can no longer find the words to speak about herself. I defy anyone to have an opinion on Simone Deschamps after attending her trial. No longer herself. Sometimes, as I was looking at her, I wondered whether she remembered what she had committed or whether she was now completely under the spell of the judicial system.

1957–1958

NADINE FROM ORANGE

It was because of the public television broadcast of André Berthaud's "interrogation" that I went to see his wife. I waited for an hour in front of her door, she didn't want to open it, she tried to get rid of me, she was holed up in both horror and terror. And then she opened the door. We spoke for a long time. While she was speaking she listened to the sounds of the staircase, the police who were still there—I remember the scene: the man in the rue des Saussaies office, pinned against the wall, under the searchlights, the barking of the policemen at the feed, they shared it all amongst themselves like a feast. Are you gonna say it, huh? Say it . . . say that you touched her . . . you bastard . . . Eighteen years later, it still lingers, unbearable. He asked to go to the bathroom and that's where he plunged his pocket knife into his heart, he who knew nothing, he knew how to do that. I remember the shock of the news, that very night, on television. The anger people felt, and their immediate refusal to be manipulated, their refusal to swallow the police's version of the story according to which A. Berthaud had committed suicide

precisely because he was guilty. This case was a great failure for the police.

Today, just as when the event took place, I see A. Berthaud's action not as the only option he had but more importantly as a refusal, plain and simple, to answer, in other words a refusal to participate in the murderous performance of the police. His limited faculties, in this instance, were advantageous: he would die how he wanted to—Yes, that very night, suddenly, there was no one left at the police station, no more "work," they were alone, they'd been "had," "duped": the man was dead. The love between the man and the child would remain unpunished, death had put an end to it. I fully believe in this love. A. Berthaud and the little girl loved each other.

The medical examination was decisive: little Nadine was not raped. Rape could have occurred. It did not occur. It's possible, probable, that the non-perpetrated rape was projected onto A. Berthaud's final act—such a violent love cannot exist without this consequence of desire—but that is for me the very reason why the rape was thwarted: the power of his love for the child.

A sentiment that is none of my business, that is nobody's business. The rape did not occur.

I suddenly think how strange it is that the murderers of the four policemen last month (November-December '79) were found within forty-eight hours while Pierre Goldman's murderers still have not been found three and a half months later.

— *How did it begin?*

— Nadine's cousins were friends with my daughter Danièle. That's how my husband and Nadine met. We all happened to be on vacation at the same time, at Notre-Dame-des-Monts. People think they had known each other for a long time, but that's not true. Nadine and André only met during the last days of our vacation, between August 31st and September 4th. It was during these five days that they grew attached to one another.

— *What happened between September 4th and Tuesday the 26th when he left?*

— He returned to Notre-Dame-des-Monts for three days without us, to see Nadine again.

— *What happened during those five days of vacation, when you were at Notre-Dame-des-Monts?*

— They became obsessively attached to one another. The newspapers didn't tell the whole truth. The little girl couldn't get enough of André either. Wherever we were, she would find us. They would play together, they would swim together. She would hang from his neck and go into the sea like that, hanging from his neck. He would put her on his shoulders. As soon as she woke up, she would come looking for him. We found it strange, even irritating. Once, when she arrived at our house, he had gone for a swim almost two miles away. I had to yell at her to keep her from walking the two miles to join him. Wherever we were, she would come. She would sneak out of her grandmother's house and come to see André. She would

have liked to sleep and eat at our house. Wherever we were, she would show up. One day, when we were having a picnic under the pines, she managed to find us. André was sleeping. We shooed her away. And then André woke up. So, of course, she stayed with us, he insisted!

— *How was André Berthaud with his own children?*

— He loved the three of us in his own way, desperately. He would have killed anyone who tried to lay a hand on his children. But I have to say that he never cared for any child, ever, the way he cared for Nadine, not even his own children. I had never seen him like that. With Nadine, it was immediate. And it was taken to the extreme from the moment he saw her. You have to tell them that he was sick. That he was a very violent man, a life-or-death man, a very simple man. What happened between him and Nadine was a twelve-year-old child falling for a twelve-year-old child. I could have never imagined such a thing. When we left Notre-Dame-des-Monts, it was terrible. She wanted to stay with him, he wanted to stay with her. They were both crying. They were completely distraught.

— *You said that he went to see her again for a weekend? And that it was after this three-day weekend with Nadine that you started to worry?*

— Yes. He wanted to see her again. He kept saying: "I want to see Nadine again." He spoke of the child non-stop. The photos of Nadine—he wanted them everywhere, on the television, on the mantel, everywhere. We tried to take them down. And that's when he

started to threaten us, to threaten our daughter Danièle. "If even one of Nadine's photos is taken down," he said, "Danièle will never see J again…" (J is Danièle's fiancé.)

— *Do you think Danièle went with him to Orange . . . ?*

— Yes, I'm sure of it. I'm sure he said to her: "If you don't come with me, you'll never see J again . . ."

— *Tell me more about the period leading up to his decision to leave with Nadine.*

— He wanted to see Nadine again, to see her again at all costs. He would talk to me about it. "I want to see Nadine again. You shouldn't be jealous of Nadine. I love her deeply. If she were fifteen or sixteen years old, I would understand if you were jealous, but not Nadine, you shouldn't be jealous." The only reason I wasn't worried those first few days was because Nadine was more than five hundred miles away from him.

— *What were you worried about in that moment?*

— I was only afraid of him bothering the little girl's parents, disturbing them, to see her again, afraid that he would get himself thrown out. I was never afraid of anything else.

— *Was his passion for Nadine growing every day?*

— Yes. We tried to cure him, the children and I. Nadine was a gorgeous little girl. We would say to him: "Nadine is a mousy girl, she's losing her teeth, Nadine is ugly." He would fly into a terrible rage. "There is no one more beautiful than her," he'd say. During that last period of time, in those last few days before September 26th, it was

terrible. He couldn't sleep. He couldn't eat. All he could think about was that little girl. We would try to make him smile, we asked him to smile. He couldn't smile anymore. "If I could just see Nadine," he'd say, "I'd feel better immediately, if I could see Nadine again, I'd be cured."

— *At that moment nothing else mattered to him?*

— No, nothing. He no longer paid any attention to us. But already, when he had come back from Notre-Dame-des-Monts, nothing else mattered to him. For example, he had dreamed of turning our son Claude, who was twelve at the time, into a champion cyclist. He had bought him all this incredible gear. Every Sunday, for years, he would train him in the Bois de Vincennes. He was so passionate about it. Once he met Nadine, he never took him again, ever. This hurt Claude tremendously. I remember that at Notre-Dame-des-Monts, Claude would chase off Nadine and would sometimes even hit her to make her leave, he was jealous of her, of course he was. Imagine, the little girl was always with us and André would always go looking for her. Nothing could keep them apart.

— *At that time, while you were on vacation, you didn't begin to worry?*

— No, at that moment in time, no, not yet. It was tiresome, exasperating, to see them together all the time, ignoring everyone else, but that was all. It was only after we got back, especially after that weekend, that André was in over his head, filled with an overwhelming passion he couldn't fight against. And that was when I grew afraid.

— *Were you ever suspicious about André Berthaud's passion for Nadine?*

— Never. People think all sorts of vile things. They don't understand. Because children are often raped, they said a child was raped. But I, even though I have never seen such a thing, would not even be able to imagine it, I knew it was something else altogether.

— *What?*

— It's impossible to say. There are no words for it. Love, yes, but not only that of a man for a woman, not only that of a father for a child. Something else altogether. I would not know what to call it.

— *Were you ever afraid for Nadine?*

— Never, I never saw anything even the least bit sadistic in André's passion for Nadine. Never. When the detectives came, I always reassured them, always, I always swore that André would never harm Nadine in the slightest. Even if I had never seen such a thing, this passion that Nadine and André had for one another, I knew that it would have never crossed my husband's mind to hurt the little girl in any way, ever.

You see, he was a bit of a simple man, a very good man—he would have given away the shirt off his back—but because he was very simple, for that reason, he was always slightly rejected by the neighbors, by family, friends. And when he met that little girl, because she was so affectionate with him, because she was always looking for him, because she was so gentle, he was overwhelmed. She kissed him as if he were her father. Hanging from his neck, I'm

telling you, all day long. She was a child, I think, who had never really reaped the benefits of having a father. Her father is a military pilot and she almost never sees him. The part she played, too, was extraordinary. Maybe they needed each other. As soon as they met, it was immediate, from the very first minute they couldn't be without each other anymore. They were overwhelmed. They had never felt the way they felt about each other for anyone else.

— *What was André Berthaud like?*

— Very simple, I told you, a twelve-year-old child. Very good. A child of divorce, raised by his grandmother. Very wholesome. He would fly into incredible rages, so incredible that if the detectives had come to tell me that he had killed someone in an argument, I wouldn't have been surprised. But Nadine, never ever would he have done her any harm. His favorite things were sports, nature. He was a man who never smoked, never drank alcohol, never drank anything but milk. Every Sunday, we went to the Sénart forest or the Bois de Vincennes. He was a man who picked flowers, you see. I was too lazy to bend down and do it, he wasn't. Do you get what I mean? He was never tired of it, he was always picking flowers.

— *The same Sénart forest where he brought Nadine?*

— Yes, you know, I have some ideas about what they did in that forest. I think he picked her flowers, told her stories, those stories for very young children. He loved those stories.

— *After his return from Notre-Dame-des-Monts, did he write to Nadine?*

— I think so. Yes. He wrote letters to Nadine. I never saw them.

— *Did the two of you ever discuss suicide?*

— Of course, as everyone does. He never understood suicide. He said that to commit suicide you needed an incredible kind of courage that he couldn't comprehend.

— *I have friends who watched him on television that night, who saw how he was insulted and treated by "people."*

— I didn't see it. People told me he was against the wall, the camera lights shining on him, and they were yelling in his face: "*Come on, just say it, say that you touched her you bastard!*" and that they all insulted him and he said nothing, that he had a terrible, terrible expression on his face. I think he killed himself because they told him that he was a criminal, that he had touched Nadine even though it had never even occurred to him to touch Nadine, ever, I would swear it, and that he didn't know that people, with their vile thoughts, could accuse him of such a thing without any proof, and even introduce him to such an idea. He went insane. I'd like to do something about it. I'd like to sue the people who forced him into that abominable act. Do you think I can?

— *I don't think so. But I encourage you to try.*

— I would like you to talk about my little Danièle, who's in jail in Vaucluse. I received letters from her work supervisors and colleagues. They all say that Danièle was a charming co-worker, perfectly responsible, and that they are willing to do whatever it takes to get her out of there. Danièle was only a child. On the one hand,

she really loved her father. On the other hand, she was afraid that he would go insane, she was afraid for herself that her father wouldn't let her see J, the young man she loves.

— *Was André Berthaud strict with his daughter?*

— Very. We're talking about an eighteen-and-a-half-year-old girl who's never gone to a dance. Not even one. He didn't want her to. He wanted her to be what she is, which is responsible. To tell the truth, she was afraid. And she wanted to make her father happy. She didn't see anything wrong in going to pick up Nadine because she too, despite her education, is still like a little girl. She had already gone with her father to help people move houses, once in Champagne, once in the suburbs. I wasn't worried. André had never been very affectionate with his daughter. With his son Claude, yes, but with Danièle, no. She wanted to do something nice for her father.

— *What do you think would have happened if André Berthaud hadn't seen Nadine again?*

— I don't know. Maybe, over time, he would have forgotten her. But I'm not sure. I don't know.

— *If "people" had not forced him to commit suicide, he would have faced only six months in jail, did you know that?*

— Yes I know. People have told me. But what does it matter now?

1961

READING ON THE TRAIN

I read at night. I've always only ever been able to read at night. I read at night when I was in school, too, the nap's night that empties the city just like the clock's night. That habit came from my mother who would tell me that I had to read outside of work hours. So I read instead of sleeping during naptime, just as later on I read instead of sleeping at night. I never read instead of writing or being bored or talking to someone. I'm just realizing that now: I never read out of boredom. I never heard my mother say to her children: If you're bored, read a book.

My mother, she never read anything. The day after she received her teacher's diploma, she shut all her books and gave them to her little sister. She said: "I never took the time to read in my life." Very quickly it was too late. She died like that, without books, almost without music, merely living the life that presented itself to her. While I read, my mother slept. We read lying on mats, under stairwells, in the dark and cold corners of the house. Those places were also where we cried when she said she wanted to die. My mother let

us do anything and read anything, too, we read what we could, what we found, what was there. She didn't control anything, ever.

One day I had a reading experience that greatly disturbed me and still does to this day. I must have been coming back from vacation, either from Italy or from the Côte d'Azur, I can't remember at all. What I know is that I had to take a train that was leaving very early in the morning and would arrive in Paris at night. I had very little luggage, mainly consisting of a canvas bag and a book. The book was enormous, it was one of a pair in the Pléiade collection. One thing is certain, which is that I had not yet read this book, that I was supposed to read it on vacation, that I hadn't done so and that now I had to read it very quickly, as quickly as possible, without delay. Because, for one, I had promised both to read it and to return it on a specific date that must have been the day after I returned from vacation, and, for another, if my promise was not kept, no other book would be lent to me from then on. I don't have any idea why my book lender was so strict, but even if it wasn't true, I absolutely believed it, I believed that I had to do it or else I would have no more books to read. I didn't have the money to buy them and I didn't dare steal them. The stakes were enormous.

The train left. Immediately I began to read the first line of the tragic book. I continued. I must not have eaten during the journey, and when the train arrived at the Gare de Lyon it was late at night. The train had probably been delayed, daylight was already gone. I

had read eight hundred pages of *War and Peace* in a day: half of the book. The memory of that journey took a long time to fade. For a while it felt like a betrayal of the act of reading. Thinking about it again today, it still disturbs me. Something had been sacrificed in my rapid reading of the book, perhaps *another* kind of reading, something as serious as another kind of reading. I clung to a reading of the story told in the book at the expense of a deep and white reading without any narration, a reading of the pure writing of Tolstoy. It's as if I had realized that day and forever after that a book was contained between two layers superimposed with writing, the legible layer that I had read that day as I traveled and the other, inaccessible. That layer, completely unreadable, we can only get an inkling of its existence when we're distracted from a literal reading, the way we glimpse childhood through a child. It would take forever to explain it and it wouldn't be worth the effort.

But I never forgot *War and Peace*. The second half of the book, did I ever read it? I don't think so. But it didn't matter. I returned the book and they lent me others. What still lingers from that day is the image of a train crossing over a plain, the great central flow of pain of the dying and defeated Prince, his own agony through the agony of all of Europe. And the memory, not so much of Tolstoy as of my betrayal of his entire being, which in fact I never really knew or liked.

I read in bursts. Some lasted ten years. In those periods I was forced to read during the day in the big university libraries of Paris. We ask ourselves for what abominable reason the big public libraries are closed at night. I rarely read on beaches or in parks. It's impossible to read in two lights at the same time, that of the day and that of the book. One must read in electric light, the room in darkness, only the page illuminated.

It would seem that I read anything any which way. In reality, that's not the case. In reality, I always read books that I was told I had to read, by people, by friends, or by readers I trusted. I was in a milieu that never looked to literary critics for what to read. When I happened upon reviews of the books I had read after the fact, I didn't recognize my reading experience. Criticism, especially written, journalistic, kills the book that it portrays. To keep the book from obstructing the critic's operation, the review immobilizes the book, puts it to sleep, distances it and kills it without understanding it, and it remains killed by the reading of the story. All literary criticism is lethal because we are not forced to read anything. And so we linger in the corridors of literature. But the book remains dead. The people who, as children, were forced to read, are familiar with that distortion of reading: It can last a lifetime. It's terrible to think about: A lifetime, the forbidding book, unapproachable, such a terrifying object.

There are people who read nothing but literary criticism, who never read the books those reviews discuss. They think they've read

the book. They talk about it. They are pleased with themselves. What can we do for those people? I think we have to let them continue, no?

We shouldn't intervene, we shouldn't get involved in the problems another person has with reading. We shouldn't be upset over the children who don't read, we shouldn't lose patience. It's about discovering the continent of reading. No one should encourage or incite a person to go see what's there. There's already far too much information in the world about culture. We must set off on our own for the continent. Discover it on our own. Bring about that birth on our own. Take Baudelaire for example, we must be the first to discover the splendor of his writing. And we are the first. And if we are not the first, we will never be a reader of Baudelaire. All the world's masterpieces should have been found by children in public landfills and read secretly unbeknownst to their parents and teachers. Sometimes, seeing someone reading in the metro with rapt attention can inspire you to buy the book. But not for popular fiction. There's no fooling anyone about the nature of those books. The two genres are never together in the same windows, the same houses, the same hands. Popular books are printed by the millions. With the same formula they've been using for fifty years, popular books fulfill their function of allowing people to access the sentimental and the erotic. After reading them, people leave them on public benches, in the metro, and they're picked up by other people and

read again. Is that reading? Yes, I think it is, it's reading your fill, but it's reading, it's going in search of reading outside of oneself and eating it and making it one's own and sleeping and falling asleep to then go to work the next day, join the millions of others, the loneliness of being just a number, the oppression.

They say that the swarm of maids from Harlem that go at night to the big stores on Broadway and Fifth Avenue spend an hour of their shift reading the books they find, they're at peace there, in the empty stores, waiting for daylight so they can go home. The image is marvellous. It would be a shame if it weren't true.

This year I reread *Confessions* by Jean-Jacques Rousseau, perhaps with less joy, but not much less, as in previous readings. Then I read seven books in a row by Hemingway, I couldn't stop myself, seven nights of bliss, irrepressible bliss. After that I read *The Diary of Samuel Pepys*, this time all the way through—feeling great disgust for the man and the mores of his era, a kind of insurmountable incompatibility. Then I returned to Diderot and Sophie Volland and I started *Tender is the Night* by S. Fitzgerald again, still with the inherent reserve I have for that author, a doubt that persists despite and perhaps because of that new utterly faithful translation.

Reading a comic book is reading. Not to be able to read anything is not to be able to rest your eyes on the writing, it's to try again and again and be rebuffed brutally from the reading every time for

reasons that escape comprehension, that are worrying, mysterious. I know a man in this condition. He's between thirty-eight and forty-five years old, he runs movie theaters, he's part of the Parisian intellectual milieu, into all things "psychoanalysis." Which is nothing unusual except that he never reads books. The paper, yes, he reads the paper. The paper is already open, you don't have to open it, and the articles are disparate, they're not presented as having a beginning and an end. You can read the paper in any direction, you read or you skip, you read more or less depending on the day. Every day my friend reads the paper. He also reads the titles of "forthcoming" books as well as their three-line synopses. Which means that he lives a safe life, he's never completely lost in conversations. What happens when he opens a book and starts to read, he translates into these words: *absolutely impossible to read.* Impossible to comprehend the meaning of the words? No, rather that it's impossible to pass beyond the printed characters to find the meaning the author wanted to insert into the phrase, the words. Which is to say, impossible to move beyond the effect of a book in order to read it? He says that might be it, but it's so strong, the forbidding nature is so strong that he cannot even express it. He is so to speak stuck at the threshold of a book, of reading.

I had to go back and forth between centuries and other centuries to finally discover that it was the end of seventeenth-century France that always surrendered me most violently to reading. When I was

very young I must have thought about Ronsard like all the other fifteen year-old girls. And then I left him behind. And then I read more and more and good, and bad, and elsewhere. And then once more I fell upon those thirty years at the end of seventeenth-century France and I reread what I had already read and it was in returning to those years that I discovered, there, my true affinity.

In those thirty years there are two writers in particular. In even their earliest works, I see the pessimism, modeled after Karl Marx, he is the basis for their writing, their primary foundation. In the profound corruption of the nobility, in the shadow of the curtains soaked with the piss of princes, each of them discovers, discovers the depths of human passion, its grandeur, its madness, its immensity.

In her work, the names are French, common for the time. They're often used. In his work, the names are Greek, the settings too, the kingdoms are Roman, but that's not important, the gasp of passion is the same, liberated in the same way, it's drawn from further back than the official history, it travels through the kingdoms, the forests of invaders, the churches, the schisms, the clans.

They are the same age, they are almost twins. He was born in 1639, she in 1634. He died in 1699 and she in 1693. She comes from the provinces, her name is Marie-Madeleine Pioche de la Vergne, Countess of La Fayette. He is an abandoned child, raised by the

women of Port-Royal, his name is Jean Racine. She lived in the Saint-Sulpice neighborhood—she buys a farm there—he died near the Saint-Germain-des-Près abbey. I don't know if they knew each other.

She started to write *Memoirs of the Court of France for the Years 1688–1689*. It reads like the title of a dissertation. I see her standing among the others with her face seemingly veiled, her primary concern to go unnoticed. He isolates himself. She receives. He writes tragedies. He produces them for the stage. She writes very short books. Like diaries. She receives people who speak to her about the king. Kings. The courts of Europe. Crimes. Poisons. Lovers. She listens to the gossip, the news. With miraculous intelligence, she detects the probable truth, which is to say that she invents things that people identify with although they've never experienced them. She positions herself in the right place when the information leaves the Court, and also when it returns, circulated by the bourgeois, the merchants, the masses of servers, the delivery men, the charlatans, the noteholders, the sorcerers, the mediators who take over the Tuileries everyday, who follow the King's Court to Versailles, Rambouillet, the Loire. It's then that she intervenes and begins to recount history. She is not part of the nobility received in Court, in fact she doesn't care to be. But many people received in Court are there to see her, if only to know what was going on while they

themselves were there but kept from seeing and knowing anything about what was happening, plunged as they were into the tumult of the event as it was unfurling.

I think again of my friend who can't read books. He says: For me, for a dagger to gleam in the dark, near a sleeping woman, I have to see both the dagger and the woman. This man is intelligent. He says that he belongs to the image civilization. In France and in the U.S. it's an affiliation claimed proudly in every milieu. My friend tells me that now I'm the one who doesn't understand anything at all about what those words mean: image civilization. A hundred times I insist calmly: I say no. I say: In the beginning there was the writer who told stories in ten words, the prehistoric writer, and now there is the writer who tells stories in a thousand words like Leo Tolstoy, or in two thousand words like Racine, or in twenty thousand words like Shakespeare, there is nothing else, no direct image, only a spoken image. I speak to him of Racine. I tell him that cinema does not exist. I tell him that one day, Jacques Audiberti came to my house, amazed because he had just understood the attribution of that word: *racine*. My friend laughs. He says that he sees, that he has an inkling of what lies within the work of Racine, that it's all clear.

I ask: But the great bodies of Racine's characters, swooning with desire, did you see them coming towards you? He tells me no. He asks me: And you? Did you see them? I say yes. Where? I say: In my

bedroom at night, suddenly, to the fabulous sound of reading, in rhythm, they emerge from the darkness and travel through time.

We still see each other every so often, that friend and I, we talk on the phone, we chat, every time we talk about reading. We laugh together. The next time I know we'll talk about the audiobooks in the U.S., reading that happens as you drive your car, as you run through the countryside, as you cook.

1985

TRUE APPEARANCES

You are here for Lapoujade to paint your portrait. But Lapoujade does not look at you. He looks at the canvas, still blank. Then he proceeds to pile paint on this canvas. All over the place it seems, at first, then in the space that will become, in a moment, the face.

He paints. We can't identify a thing. He continues to amass colors. Any colors at all apparently, then certain preferred colors.

It was Kandisky, I think, who said that the painting is already in the paint tubes before it is on the canvas. Where are we, where is Sartre, before appearing so phenomenally on Lapoujade's canvas? He is, we are, blended within Lapoujade, we circulate through Lapoujade. I have never felt so strongly the feeling, the sensation of being an osmotic and physical phenomenon, of being soluble, as when I am in front of this painter.

Lapoujade continues in your presence to build—in your presence—and without a glance at you—this astounding disorder from which you will emerge. It's not a rough draft. It's the Nature of Things from which all that has been created emerges: you, me, a bottle, Aristotle, a cat.

He's forgotten you.

In a gathering of all his emotional, physical forces, with all the power in his muscles and nervous system, Lapoujade rebuilds an imaginary Sartre. And for this, though he needs Sartre to be present, there, in the same place as him, Sartre, the absolute proof of Sartre's existence, he doesn't need to look at the Sartre who is present. For as calm as your mood may be, as normal your behavior, the fact remains that this mood and this behavior are accidental, are fragmentary. There's nothing to be done: you are never, even during an important moment of your life, anything but an insufficient illustration of yourself, a sign, a clue, one of a thousand in a whole that will never, of course, find itself, at a given time, expressed. Given that, how can you get as close as possible to this whole? In the eyes of Lapoujade, I mean? Indeed, therein lies the Lapoujade miracle: in the memory that others have of you. Of all the Sartres seen, heard, read, met, juxtaposed with all the states of this "matter," Sartre can appear and survive beyond his psychological existence. Lapoujade silences his accidental memory, he attempts to access his global, eternal memory of Sartre. But Lapoujade can only access this memory-idea, antithetically, by first forgetting Sartre, and not "thinking" about him afterwards. Thinking puts a stop to memory, fixes it, contemplates it, catches it in its net and, of course, freezes it. No, the thought of Sartre must not be thought, it must pass directly from the image to the tool, to the hand. No delay between these two moments: seeing and showing.

Lapoujade at work is unforgettable. He says: "I don't like to decide anything in advance, so don't be surprised by the way I paint." It's very impressive. You are there and, once more, he doesn't look at you—sometimes a little, at the end. You would disturb the absolute figure of who you are within him if he were to look at you. The canvas is still formless. There is jazz playing, loud, strong. Lapoujade, to the rhythm of the jazz, steps toward the canvas, strikes it with the paintbrush, moves back, returns, always in step, shapes the air in front of the canvas with his two hands, and in the shadow of his body, lays the first stone of the structure. Still to the same jazz rhythm that clears the minds of those who dance to it.

Lapoujade is very far away from you, he's with the painting. The paint flows through the world in rivers and streams, he captures it, he draws from it. He doesn't think. A man who, without thinking, renders the pensive Sartre, it's unforgettable. Lapoujade does not remember a thing, if he's seen you before it was in another life altogether, the other one, in which he does not paint. Of all the accidental Bachelards, Bachelard will emerge. And he will emerge from Lapoujade as he would from any other who approached him in the same way. Made by all, and for all, Lapoujade makes you.

The effort is colossal. It is two-fold for this "builder," as Sartre calls him. First, he must break the habit, the laziness of his vision, lose sight of his psychological countershot, his impurity. Second, Lapoujade must, in his turn, break free from the shackles that confine him and embark on his research like a stranger.

"Lapoujade," Sartre says, after seeing his exhibition entitled *Emeutes*, "that endless crossroads between man and the world, is a traffic jam . . ." I think that applies to this exhibit here, where Lapoujade has rendered one particular instance instead of a thousand others: one instance is endless, a crossroads also, overloading itself.

And so, dancing all the while, Lapoujade makes progress, he is still fighting. But you will soon become the stain on the wall, the lumps of plaster that, as soon as our vision assembles them into a figure, can no longer be separated. You will coincide with the accident that gave you this face, that gave the wall the face you've just discovered. The same, exactly.

Before Lapoujade, you were that Russian dog drained of its own blood and fixed in a state of apparent death. Now he is re-injecting your blood, pumping it slowly back into you. The heartbeat monitor had flatlined, now there's a palpitation, then another, first sporadically, then more and more regularly, then finally at a natural rhythm. It's done. It's remarkable.

1965

THE MEN OF TOMORROW

What we've watched on the Antenne 2 show *Les Sept Chocs de l'an 2000* is one possible direction of the future, not the only one. It could be that humanity is at the infancy stage of electronics but that, very quickly, like a child growing up, it will get bored of playing. Robotics, telematics, computer science are developments that, at each stage, are made once and for all. Because of one man's invention, all other men will be deprived of inventing. Everything seems to be done in order to spare man the effort of living, both in his work and in his daily life. It's terrible.

In the show, we see the family unit expand. And yet this is not liberating as they would like us to believe, but an additional burden. When is man alone in all this? Alone before God, before his own immensity. When we talk about the issues humanity faces, we are framing things the wrong way. The everyday issues that arise for the individual, meaning those related to his purpose and his futility, are crucial issues for all of humanity, and they are mundane, they are the most observable, the most frequent. With each of his tragedies,

with each of his problems, man bangs up against his own definition: What am I doing here?

Everything will be done to ensure man forgets the Pascalian perspective of his existence, which is to say his constant struggle with himself. To think, to read, to write, to travel, to commit suicide, to love, to construct, to deconstruct, to destroy, to face this contradiction in his blood, in his mind, and to stand tall before the idea of God, and above all above all never managing to solve a thing, and always always trying, trying to solve everything, that is the problem, and the only one, in every case, man's problem in every case.

One moment remains identical, for all men, for all time, and that is death. What I am saying has nothing to do with pessimism, it's faith in man, it's pure optimism. Let people keep to themselves their misguided thoughts, those grand sterile ideas, those grand sentiments made for public political discourse on happiness. Let them act as if man could be determined from the outside, it makes no difference to us. This notion of happiness surpasses everything people can say about it, it's beyond them, it's beyond any logic, beyond everything. Happiness is unattainable, it's extraordinarily mysterious, brilliantly mysterious. Let us never utter this word again.

As a child, I lived at the bottom of the Elephant Mountains, on the border of Siam. For the Indo-Melanesians (many Cambodians had

children with the Chinese), death reigned over people of all ages. Children died, many of them, every day. We had just vanquished malaria but cholera and amoebic dysentery reigned like suns and, beneath these suns, villages died and laughed. I can still hear the laughs of the women and children who accompanied us when we walked through these villages.

There are no longer any villages in Europe. There's nothing but television. (Actually, this summer, in 1985, the TV shows have been so bad that people have started to read again. Luckily there was this show on the year 2000 produced by Pascale Breugnot, which was very good.) Television is like an herbicide. It has killed all social life. When we see each other now, we talk about television, about what we've watched. Television is nothing, nothing. And yet we watch it anyway, and we watch it along with the rest of the country, we're there listening to the same things at the same time. And also learning things together, which isn't so bad.

I can't do without television. I know there are other people like me. Watching it is like sleeping upright. It's seeing nothing at all, but still sitting there, doing nothing else. It's too early in the day to read, and seeing friends in Paris is still impossibly difficult. First off, it has to be planned weeks ahead of time. And on top of it, all my friends are always watching television.

But we still have telephone calls, fortunately, which can stretch into the night. Our day-time friends have become our night-time friends. You can call them until two in the morning. You can say that you're "living but not really living," that you're getting by, as during the Occupation. You share recommendations with each other for plumbers, electricians, maids, the names of legible books.

We could still go to live shows, but who goes to those? Do you know anyone who's been to a live show? To the Vélodrome d'Hiver or the one in the summer? There is still Higelin who I adore, but the idea that Diane Dufresne, who I also adore, was at the Fête de l'Huma, I couldn't stomach.

The Pont Neuf wrapped in white by Christo, yes, I went to see that. The cloister suspended over the river, yes, that remarkable thing, that stone wrapped in silk, that beauty all covered up, hidden away, forgotten, and present.

I've digressed from your questions, but it doesn't matter. People say I never respond to the questions I'm asked. It doesn't matter.

If man plays the game, if he becomes what the show foretells, it won't take long for him to forget his roots in his culture, his civilization, etc. That man, I don't really see him as a man anymore, I see him as returning to another species, one he previously belonged to during his thousand-year-old trajectory. How bizarre, a man with no depth of field, a flat man, cut off from memory, who merely eats

and sleeps. Indeed, insomnia won't exist anymore in the year 2000, 2050. Therefore, no more dreams or nightmares in our sleep.

And what about God, what's the plan there? This word that opened up the legendary void of man's destiny, from person to person, will it still be uttered? By that point we will have explored all the planets of our solar system and we will know they are devoid of life. Therefore either God reigns over a void, suddenly filled, in which we are the sole accident, or else he reigns over us only and becomes a regional God, and no one will believe anymore, as if it were possible not to believe. There, let it be said, no "progress" whatsoever is possible.

That's what I think.

Not to believe now is still to believe. Our current non-belief in God is an Everest of belief compared to that of 2050. You would see then what it would mean not to believe in God at all, but how can you even imagine that? It would mean no longer populating, no longer "doubling" the nights, the days, the things, the trees, the children, the women, the passions, through an eternity of experiences. So it would mean no longer writing. But, in the end, maybe we'll do away with the human race once and for all.

The cycles of desert and ice will return. Deep down, that's what everyone's thinking about, like in the year 1000. The same thing: the

end. That is what people summon and await. Humanity likes to live in suffering. I think we like to live in suffering, that to live is to live in suffering. But to live well, nobody knows what that means.

We can still talk about it. When I talk about it, at least, everyone understands what I'm saying. I'm not talking about the little house on the corner, but about *that thing, inside of us, that causes suffering all over the world*, that thing without which we would be forever separated from our genius, it doesn't have a name, it doesn't reside anywhere, it commands writing and speech and it's mute, it's unknown, it's suffered.

To be a genius is to take the genius outside of oneself and put it on a canvas or inside a book. It's to feel that the outside of oneself and the inside of oneself are interconnected.

Hello to Tjibaou, by the way. In this moment, I'm awaiting the results of the New Caledonia election and I wanted to tell you, that I love you.

1985

THE RIGHT, OUR DEATH

What's the difference between a lover and a husband? J.-L. B. asks me. I don't know. Night and day, says J.-L. B. Yes, it's nice, simple. That's not all. I've just seen Mitterrand in Moscow and Chirac in Sarcelles, I don't know if it's a TV "stunt," but this stunt is dazzling. Mitterrand, fine as amber, astute and clear, in precise terms, spoke of the entire world. Chirac, a boy-scout, with old-fashioned language and profound stupidity, was still speaking about Mitterrand, yes, and still about Le Pen. What was he going on about? I don't know. What I did was walk away from the TV and start to write this, that if the French continue to feel spiteful toward the Socialist Party, to vote in the hopscotch of the right, they should know what and who they would be deprived of if the Right comes to power.

Seeing the "private road" signs of the countryside, a friend of mine would always say: "*And so, dear friend, you asked for it, don't come crying back when you'll be deprived of me.*" I am here to tell you: if you continue like this, you will find yourself face to face with the scarecrows Gaudin-Pasqua-Lecanuet, and alone with them, and

it will be too late, you will be part of a society that we don't want to know, never again, and consequently you will be members of a society deprived of us: without men who are veritably and profoundly intelligent, without intellectuals, yes, that's the word, without authors, without poets, without novelists, without philosophers, without true believers, true Christians, without Jews, a society without Jews, do you understand? without Arabs, without black people, without Maghrebis, without Guineans, without, let's say the word, internationality, without Chileans, without Chinese, without Cambodians, without Palestinians, without Lebanese, without Afghans, without Nicaragua, without Argentina, without Brazil, without Colombia, without any America, without Germany, without Italy, without Poland, without Sub-Saharan Africa, a regional society that will never venture toward the outside, that will remain sitting in front of its own door waiting for death.

1985

THE HORROR OF SUCH A LOVE

They told me: "Your child is dead." It was an hour after the birth. The Sister Superior went to draw the curtains, the May day entered the room. I had glimpsed the child when he passed in front of me, in the arms of the nurse. I hadn't seen him. The next day, I asked: "What was he like?" They told me: "He's blond, reddish blond, he has high eyebrows like you, he looks like you." "Is he still here?" "Yes, he's here until tomorrow." "Is he cold?" R. answered me: "I didn't touch him but he must be. He's very pale." Then he hesitated and said: "He's beautiful, probably also because of death." I asked to see him. R. said no. I asked the Mother Superior, she said no, that there was no point. They had told me where he was, to the left of the delivery room. I couldn't move. My heart was very tired, I was lying on my back. I wasn't moving. "What does his mouth look like?" "He has your mouth," R. said. And every hour: "Is he still here?" They said "I don't know." I couldn't read. I looked at the open window, the leaves of acacias that were growing on the embankments of the railway line that ran along the hospital. It was very warm. One night,

Sister Marguerite was on duty. I asked her: "What are they going to do with him?" She said to me: "I am very happy to be here with you, but you have to sleep, everyone is asleep." "You are nicer than your superior. You will go fetch me my child. You will leave him with me for a moment." She cries: "You're not serious?" "I am. I want to have him here next to me for an hour. He belongs to me." "That's impossible, he's dead, I cannot give you your dead child." "I want to see him and touch him. Ten minutes." "It's no use, I won't go." "Why?" "It would make you cry, you would be sick, it's better not to see them in these cases, trust me." The next day, in the end, they told me in order to shut me up: they burn them. It was between the 15th and the 31st of May 1942. I said to R., "I don't want any more visitors, only you." Still lying on my back, facing the acacias. The child had come out. We were no longer together. He had died of a separated death. An hour ago, a day ago, eight days ago; death apart, death of a life that we had lived nine months together, a life he had just left separately. My stomach had fallen back heavily on itself, a worn cloth, a rag, a shroud, a slab, a door, this void of a stomach. It had carried this child though, and it was in the viscous and velvety heat of its flesh that this marine fruit had grown. The light of day had killed him. He had been struck dead by his solitude in space. People said: "It's not so terrible at birth, it's better this way." Was it terrible? I believe so. Precisely because of that: the coincidence between his coming into the world and his death. Nothing. I had nothing left.

That void was terrible. I hadn't had a child, not even for an hour. Forced to imagine everything. Immobile, I imagined.

The child who is here now, sleeping, that one, just now, laughed. He laughed at a giraffe someone had just given him. He laughed and there was a laughing sound. It was windy and a little bit of the laughing sound reached me. So I slightly lifted the canopy of his stroller, I gave him his giraffe again so that he would laugh once more and I shoved my head into the canopy to capture all of the sound of the laugh. Of my child's laugh. I put my ear to the shell and I heard the sound of the sea. The idea that this laugh might be dispersed in the wind, that was unbearable. I captured it. It was mine. Sometimes when he yawns, I breathe his mouth, the air of his yawn. "If he dies, I will have had that laugh." I know they can die. I measure all the horror of such a love.

1976

ME

My personal stance on the American raid on Libya is completely different from that of my colleagues at *L'Autre Journal*—as you already know from Michel Butel's editorial in issue 9, which includes my own article, "Le froid comme en décembre." I also expressed this same position in an interview with François Mitterrand on Reagan and the Americans. I suggested this topic to François Mitterrand because as it happened I wanted to speak with him about it. But today I am publishing this text separately from our interview (which is forthcoming) because it seemed impossible for me to fit them into the same article, the political interview on the one hand, and these very personal opinions on the other, even if they were already implicit, but not with the same brutality and indecency.

My position, both physical and moral, on the event at Tripoli, creates a rift between me and the others, from which I should suffer. But I do not suffer. For which I should apologize. But I do not apologize. Which should make me afraid. But I am not afraid. I agree. I know that I have crime and maliciousness in me. The rest I

don't know. I stand by every part of myself, this is how I get by. Different from you. After Seurat's murder, for three days I was gripped by hatred, the need to kill, three days with the dagger, the blood, and at ease, not disgusted. In the wake of the raid on Tripoli, nothing came unraveled in me, I was reassured, as when an operation has just been done on a sick organism that allows a defective circulatory system to normalize again. I don't know what non-violence is, I can't even comprehend it. Peace with oneself, I don't know what that is. I have only tragic dreams, of hatred or of love. But I don't believe in dreams. I write. What moves me is myself. What makes me want to cry is my violence, is me.

1986

SUMMER 80

At the beginning of the summer, Serge July asked me if I would consider writing a regular column for Libération. *I hesitated, the idea of a regular column scared me a bit, and then I said to myself that I could always try. We met in person. He told me what he was hoping for, which was a column that wouldn't discuss current events, of a political or other nature, but a sort of news report parallel to that, on events that interested me and that had not necessarily been captured in the mainstream news. What he wanted was this: every day for one year, no matter the length, but every day. I told him: A year is impossible, but three months, yes. He said to me: Why three months? I said: Three months, the span of the summer. He said to me: Okay, three months, but every day then. I had nothing to do that summer and I almost yielded, and then no, I was afraid, always that same panic at not having the entirety of my days at my disposal, opening onto nothing. I said: No, once a week, and the news that I wanted. He agreed. I covered those three months, except for two weeks at the end of June and the beginning of July. Today, Wednesday September 17th, I am*

handing over the texts of Summer 80 *to Editions de Minuit. This is what I wanted to talk about here, this decision to publish these texts as a book. I hesitated before making the decision for these texts to be published as a book, it was difficult to resist the lure of their loss, not to leave them where they were published, on one-day paper, scattered in issues of newspapers doomed to be thrown away. And then I decided that, no, to leave the texts in that inaccessible state would be to prove even further—and now with a suspicious ostentation—the very nature of* Summer 80, *namely, as being a mere wandering off into reality. I said to myself that enough was enough with my films already in tatters, dispersed, without contracts, lost, that it wasn't worth going any further in making a career out of negligence.*

It would take me an entire day to enter into the current events, it was the hardest day, to the point that I would often give up. It would take me a second day to forget, to emerge from the darkness of these facts, from their promiscuity, to regain the surrounding air. A third day to erase what had been written, to write.

1

So, here I am, writing for *Libération*. I have no topic in mind for this article. But perhaps that isn't necessary. I think I'll write about the rain. It's raining. It's been raining since June 15th. We should write for newspapers the way we walk down the street. We walk, we write, we cross the city, it's crossed, it ends, the walk continues, in much the same way we cross time, a date, a day, and then it's crossed, ends. It's raining on the sea. On the forests, on the empty beach. There are no summer parasols, not even closed ones. The only movement on the hectares of sand is of the summer campers. This year they are very young, it seems to me. From time to time the counselors, to keep sane, let them loose on the beach. They arrive screaming, they gallop through the rain, run along the sea, howl with joy, they fight with the wet sand. After an hour they're useless, and so the counselors bring them in, make them sing "Les lauriers sont coupés." Except for one, one boy who watches. You won't run? He says no. Okay. He watches the others sing. They ask him: You won't sing? He says no. Then he goes quiet. He cries. They ask him:

Why are you crying? He says that if he were to say it they wouldn't understand what he was saying, that it's not worth him saying. It rains on the Black Rocks, the clay hills of the Black Rocks, that clay, punctured all over with freshwater springs, that advances little by little, glides toward the sea. Yes, there are several miles of these clay hills brought forth by the hands of God, enough to make housing projects for one hundred thousand inhabitants, but here, for once, no, it isn't possible. It's raining also on the black granite and on the sea and there is no one to see it. Except the child. And me who sees him. Summer has not arrived. In its place, this unclassifiable weather that we don't know how to describe. An opaque wall of water and fog erected between men and nature. And what is this concept of summer anyway? Where is summer when it's late? What was it when it was here? What color, what heat, what illusion, what subterfuge was it made of? The sea is in the spray, concealed. Le Havre is no longer visible, nor the long procession of oil tankers stopped before the Port of Antifer. Today the sea is just rough. Yesterday there was a storm. From afar, the sea is sprinkled with white breaks. Up close, it's entirely white, profusely white, endlessly dispensing armfuls of whiteness, vaster and vaster embraces as if gathering and bringing into its reign a mysterious lifeblood of sand and light. Behind that wall the town is full, confined to its rentals, the gray hostels of its English-style streets. The only movements those dazzling crossings of children who wash over the hill in endless

cries. Since July 1st the town has gone from eight thousand to one hundred thousand inhabitants, but you can't see them, the streets are empty. There are rumors: some people are leaving, they're discouraged. Business is shaky, since July 1st the prices have doubled here, in August they'll triple, if they leave what will become of us? The beaches are returned to the sea, to the playful bursts of wind, of salt, to the vertigo of space, to the blind force of the sea. There are heralds of a new happiness, a new optimism, it's already circulating within the disaster each day sadly reported by those in power. In the streets people walk alone in the wind, they are wrapped in K-Ways, their eyes smile, they look at each other. With the storm, news arrived about a new effort being asked of the French in light of a difficult coming year, bad terms, days meager and sad with increased unemployment, we don't know anymore what effort they're talking about, why this year is for some reason suddenly different, we can no longer listen to the man who speaks to announce that change is coming and that he is here with us to face this adversity, we cannot see him or listen to him any longer. Liars, all of them. It's raining on the trees, on the flowering privets everywhere, all the way to Southampton, Glasgow, Edinburgh, Dublin, these words, rain and cold wind. If only everything were made of the boundlessness of the sea and of the crying child. The seagulls are turned toward the open sea, feathers smoothed by the strong wind. They remain thus poised on the sand, if they flew against it, the wind would break their wings.

One with the storm, they lie in wait for a change in the rain. Still that lone child who neither runs nor sings, who cries. They say to him: Won't you sleep? He says no and that the tide is high right now, that the wind is stronger and he hears it through the canvas. Then he goes quiet. Might he be unhappy here? He doesn't respond, he makes a gesture of who knows what, maybe to express a slight suffering, maybe to excuse himself for not knowing, he smiles also perhaps. And suddenly they see. They don't question him anymore. They retreat. They leave him. They see. They see that the splendor of the sea is there, there too, in his eyes, in the eyes of the child.

2

Fog covers the entire sky, it's unfathomably thick, as vast as Europe, static. It's July 13th. The French athletes are going to participate in the Moscow Olympic Games. Until the last minute we had hoped that some would not go, but no, it's been confirmed. For a long time this morning sunlight slid between the storm and the wind. Two hours. And then it was covered back up. They found Mr. Maury-Laribière. Even if I were incited to murder him, even if I were shown Maury-Laribière crying in his workers' arms, I would let him live. I would not kill anyone, not even Schleyer, not even those who kill, never. I can see that a political crime is always fascist, that when the Left kills it is engaging with fascism and no one else, absolutely no one else, that the elimination of life is a fascist game like shooting pigeons and that it happens between them, between killers. I can see that every crime reveals the essential stupidity of the world, that of force, weapons, and that most populations fear and revere this stupidity as if it were power itself. It's shameful. The child who keeps quiet is still looking all around him, at the high sea, the empty

beaches. His eyes are gray like the storm, the rock, the sea, the intelligence inherent in matter, in life. Gray, gray-colored eyes, like an exterior tint imposed on the mythical force of their gaze. They let him leave the tent, this one won't run away. They ask him: What are you thinking about all the time? He says: Nothing. Inside the tent the others are still singing "En passant par la Lorraine avec mes sabots." In town people are loading their bags into the trunks of cars, the anger of the patriarchs is inflicted upon the bags, the women, the children, the cats, the dogs, in every social class the men scream when it's time for the bags, sometimes collapse from screaming and go into cardiac arrest while the women, a small fearful smile on their lips, apologize for existing, for having committed the children, the rain, the wind, this entire miserable summer. It rained the whole day yesterday. And so people went out into the wind and the rain, in the end they made up their minds. They covered themselves in everything they could find, raincoats, blankets, shopping bags, tarps, and hordes of migrants were seen walking, heads down against the wind and the rain, all looking shockingly alike. We all look like poverty, we trickle like the walls, the trees, the cafés, we are no longer ugly or beautiful, neither old nor young, we are the three hundred thousand individuals from the Trouville-Deauville area relegated to this summer of rain. Ninety percent of us are families. The problem is knowing where to put yourself, what to do with your car and your own mass. A café is ideal, with an

espresso, three francs, you're sheltered for two hours, it's cheaper than the parking lot. And so the cafés eliminated coffee. The notice is on all the percolators: Out of order. They're serving, but alcohol. You arrive at midday: A raspberry liqueur? Pear? Three hundred thousand people, that's more than Lille, more than Brest. What are we hoping for? It's complicated. This is not the kind of weather that we could say is more or less terrible, this is weather not yet identified, mysterious, not yet designated but perhaps about to be, yes, that's possible. Can you think of something? What I can kind of see is that the descriptor, once identified, would lose all general meaning, would be driven by the weather itself, by the weather alone. Families have picnics in the Decaux shelters, in the truck garages, the bombed-out hangars of the old Port of Honfleur, in the rust, the nettles, the butane warehouses, the beach huts, the construction sites. What's become of those nights, those idle and slow nights of the summer, stretched out until the last glimmer, until the vertigo of love, its sobs, its tears? Nights written, embalmed in writing, now readings with no end, no limits. Albertine, Andrée were their names. Those who danced before him who was already infected with death and yet who watched them, and yet who was there, before them, destroyed, obliterated by suffering, already writing this book of their past, of their encounter, their drowned gazes that no longer saw a thing, their parted lips that no longer said a thing, their bodies alight with desire, the book of love that very night in Cabourg.

Brutal is the arrival of the night now. There are still those defunct casinos, the monumental void of their ballrooms. There is still the spending of money. The gambling halls are full, behind the heavy curtains Keith Jarrett's piano, the brilliance of chandeliers. The petrodollar skyrockets. From there, from behind the sound of gold, they can't hear the ocean or the rain. Knowledge of Arabic is obligatory. No legal wives, instead the great mistresses of Paris, the whip handlers, the priestesses of perverted death games. Two million is the price of a weekend in Kuwait. Another day spent among all this. The day of July 14th, 1980. The sea is less white, the waves are shorter, harsher. The horizon is back and so is the long line of oil tankers in front of the Port of Antifer. Against the gray of the sky is a kite like those in China perhaps, it has a large red triangular head, of a snake, and a very long, large body, an unfurling of blue cotton. Like every day, the contingents of summer campers are unleashed onto the beach and let loose colors and cries. Today they watch the kite and the man maneuvering it by its line. The lone child is there too, he's watching the kite too, he's standing a bit apart from the others, he isn't doing it on purpose, he's always as if on a slight delay, just behind the others as they move toward the object of curiosity, but perhaps it's actually the opposite, an interest so consuming that it paralyzes him, keeps him from moving. He doesn't know that on this beach there is someone watching him. He turned around and looked behind him; the wind, it seems, changing directions. And

then, there, it happened, the kite wants something with a sudden force, it rushes, it plunges, it noses through the air, it pulls, it searches, searches. The child goes toward the kite and stops. It's the first time I'm seeing the child's body from so close. He's thin, tall. Probably six years old. Heart racing. Fear is in the air. The kite tries to overcome an obstacle, this man holding it back, it tries to break away from this man. In the child's eyes there is suffering. Now the man gives in abruptly, he yells, he lets go of the line. The kite takes off in a mad dash toward the sea, and then it is caught in the traps of the wind, it falls dead. For a few seconds stupor immobilizes the children and then they start up again, they shatter the beach, the entirety of time, space, the world. Spurred on by an overwhelming urge, some undressed and entered the sea, others entered the sea without undressing. The counselors yell: Everyone together! Nothing. The counselors dole out slaps in all directions but the children are faster than everything, than the counselors, than light. The counselors fall into the sea. Afterwards, everyone laughed, the children, the counselors, the lone child, me watching him. Afterwards, the children were more tolerable, they pretended to be in action movies, pretended to be cops, gangsters, to skin each other alive, to shoot each other, to yell death threats, without pretext or explanation. There was an hour of sun, warmth enveloped the town, there was no more wind all of a sudden and they told the children that they could swim. The lone child is in a white bathing suit. Thin, yes.

His body sticks out, it's too tall, as if it were made of glass, it's already clear what he will become, the perfection of his proportions, of his joints, of his muscles, the miraculous fragility of all his ligaments, the folds of his neck, his legs, his hands, and his head carried with confidence, like a lighthouse, or a flower on its stem. The wind started up again and the sky turned black once more. The torchlight procession was done under umbrellas and the fireworks were moving, more sad and more beautiful than in books. And the small children sang, "En passant par la Lorraine avec mes sabots." And at the Savonlinna Opera Festival, fifty thousand inhabitants, near the sixtieth parallel north, in the middle of a desert of lakes and granite, Mozart's *The Magic Flute* ended for all eternity. They passed the last of the rows of ships, it was midnight, the sun was setting in a vast blue twilight, translucent like at the creation of Earth. In Paris, it rained on the parade, on the French army, the new anti-aircraft tanks, torrential rains came down, on the President of the Republic too. It rained telegrams from Brezhnev to the German and French presidents congratulating them on having finally understood that the greatest danger to the European states was the American stranglehold on Soviet Europe. These days Brezhnev is going through a strange phase of mystical and polyfloral congratulations. Afghanistan is disappearing from the world map. We are in Moscow with the joyous Georges Marchais. July 19th. On the television, the opening ceremony of the Olympic Games. Brezhnev is there, dead, eyes

closed, they propped him up and a speech came out of his waxen mouth, his voice toneless. The hundred thousand Soviet delegates were there too and sometimes we were able to tell the difference between the applause, the starting signal, and the lesson learned. And we were afraid, we were frozen with fear faced with what we saw, that population given over to that thing without a name, that misfortune of mankind, of the history of mankind and the incommensurable weakness of mankind, the vile treatment man inflicts on himself. It was July 20th. During the night the rain fell for eight hours straight, at first childish, light, almost timid, and then comfortable, tenacious, and old. And then, from that rain came the sun, haggard. And that night there was the immense carnival of a white storm, it arrived brusquely in the light. The sea became an endless theater of rain. Under the awning of an abandoned building was the child. He was looking at it, at the sea. He was playing with pebbles gathered on the beach. He was wearing a red piece of clothing. His eyes were brighter than usual, more frightening too because of the blind magnitude of what there was to see.

3

The storm was sudden, the gales blew in as if from a spectacular wind tunnel, it didn't let up for seven straight hours, it took the tent off a carousel, some caravans, some yachts, a child, it didn't break any of the Antifer oil tankers. Contradictory forces were at play between the winds, the currents, the gods, the rain stopped, the sky opened and the sun appeared. It's here, billions of years old, naked in the sky. And beneath it are the people. By the thousands, they left their houses and covered the beach with their outstretched bodies. They were heard saying: Ah, the sun finally, I need the sun, the sun is everything. Then they stopped talking. And boredom spread over the beach, the boredom of constant beautiful weather along these latitudes, of a new stillness in these typically restless skies, restless with rain. The child who keeps quiet is confined with his summer camp in a precise perimeter. The acres of sand have been returned to the adults. It's true, children create a disturbance, you can't sleep or read or speak when there are children around, children are almost as terrible as life. Once upon a time, said the young counselor,

there was a little boy named David, he was blond, he was good, he had set off to travel the world on a big boat they called the Admiral System, when suddenly the sea turned rough, very rough. In Iran, the government of death has taken power for good. The strongest party is recognizable by its death potential, its varying faculty to administer death. They've killed pickpockets, they're killing drug traffickers. And they're killing homosexuals. Because in Iran, as in the Soviet Union, the de facto confession of homosexuality in the face of popular and government opprobrium is a radical political act serving as a supreme example for the expression of all the other freedoms of man, everything from the choice of one's spirituality to the conduct of one's body. It's in the logic of fascism to punish homosexuals and women. The sea is a milky blue, there is no wind to carry off the young counselor's story, other children have been alerted and come to listen too, the sailboats are asleep, mist drowns the horizon and the procession of my behemoths, four hundred and fifty yards long, seventy-five yards wide, my gentle, long petroleum whales, brittle and blind like slow-worms made of glass, as dangerous as fire, volcanoes, the devil. In the hands of commanders of wealth who know nothing of the power of the sea. The power of the sea is not very well known, it's only starting to be known. Until now the shapes and the proportions of ships were calculated in order for man to be able to thwart its power, not give rise to it. But now, the sea has finally found prey up to its standards. The sea was

so rough, continues the counselor, that the Admiral System sank, everything aboard the Admiral System had died, the people and the cargo, except him, our little David. And now, it just so happens that a shark goes by, sees him swimming and crying and who can explain what's going through the shark's head on this day, but he says to David, come on, get on my back little child, I'll give you a ride to a desert island, and off the two of them go and the shark tells David that he knows the area well because he patrols the many schools of herring in the ports of Long Island and Nantucket and that he had seen a few shipwrecks in his day, oh had he seen a few. I don't know a thing about Antifer, except for the word, it has no inflection, it's strange, as if constantly on the verge of making sense without ever getting there, unforgettable. The child is there, the one who doesn't speak. Is he listening to the story of David? The counselor says that the shark is traveling very fast over the surface of the sea and that he causes two snowy sprays to rise on either side of him, that he shouts about how he has spent his life under the port facilities in order to spy on the fishermen and warn the herrings. The counselor tells the story very slowly and very well, she wants the children to remain calm, and they remain completely calm. Ratekétaboum is the shark's name. Rakéboumboum, repeat the children. Does the child who keeps quiet listen to the story? It's impossible to know how he perceives it, it's almost as if he were listening to a story for the first time. He doesn't move, he watches the counselor, but nothing can be

glimpsed in his gray eyes. Perhaps he lacks feeling, it's possible. Perhaps nothing in him connects to the story, perhaps he doesn't yet have the leisure, the time, yes, the time, to slip outside of himself, that's also possible. "Him," that word, it's still what he watches, what he sees, this abduction of what is exterior to him and this devouring deep within him of what he watches and what he sees, those two inseparable movements of equal force. The weather is so calm that flights of swallows appear above the beach to hunt insects, they think it's a huge pond, they see they're mistaken, head back toward the hills. The shark scolds the crying David, he tells him it isn't nice to remind him that he's the one who swallowed all the passengers of the Admiral System, including David's mother and father, and so David apologizes to the shark and holds back his tears as the island appears on the sea, it's a tropical island, like a bouquet of palm leaves, and now go and take a swim all of you, says the counselor, to be continued. Cries of outrage and they all throw themselves into the easy, warm sea. And then came July 25th, without warning, like the storm, sweltering. The sun was there, as permanent as the law, and it was eighty-five degrees in the shade. People said you had to be prepared for anything on this seemingly welcoming coast, even the herrings won't spawn here, they go to the Irish coast, they circumvent this coast like they did in the Cretaceous Period when it was inaccessible. And then the beach was abandoned and people went to lie in the shade of the trees, the tents, the walls of those large

neglected hotels behind which one awaited nightfall before step-
ping out around fifty years ago. And then, once more, as soon as the
heat broke, the people returned, the beach was once again covered
by the bodies of the many people who took their vacation at any
cost no matter what their place in society. And sprawled out on that
beach, there was a quotient of intelligence inferior to what it would
have been had these people been for example Chaldeans, Vikings,
Jews, Shiites, Manchu adoring their gods or their dead ten thou-
sand years ago. Of this, I am certain, and this, I know. On this side
of the beach they're all rich because they're equipped with the intel-
ligence developing now, an intelligence that serves its subject, the
intelligence of positive, dependable foolishness, not endowed with
thought but with irrepressible logic, excluding from its ever nar-
rower trajectory everything that does not concern its own causality,
this I know. This is who these people are, superiors who have supe-
riors and who sign their letters: Please accept, Mister Superior, my
most shriveled salutations. They are the millionaires here. They are
nothing but themselves now, no more than themselves, to the point
of no longer being able to conceive that what they have done wasn't
worth doing, the missile homing devices, the international bank
cards, the coffee mills. Faced with his own creation, man's great
awareness has been abandoned. Yes. So, last night, the members of
the jury in Moscow once more took a very long time to reach the
conclusion that the young Russian and German gymnasts were

perfect but that it wasn't enough, and that this little Romanian, this Nadia Comăneci, should not be punished for her inexplicable grace falling outside the athletic criteria of the regime. And the nights were hot, and the days too, and the little children of the summer camps napped beneath the blue and white tents. And the child who keeps quiet had his eyes closed and nothing distinguished him from the other children, he had a certain gravity about him, as though concentrating on a secret thought while asleep. The young counselor approached the child. And he opened his eyes. Were you sleeping? He thinks, always that smile full of apology, he doesn't answer. You don't know when you're sleeping? He thinks again, he smiles again, always this fear of wounding, he says he's not really sure. How old are you? He's six and a half. The counselor looks at him intensely and she smiles back at him: We have to tell stories to children, you understand that, right? He nods yes. The counselor continues to look at him, her lips tremble. Can I give you a kiss? He smiles, yes, she can. She takes him in her arms and she kisses him very hard on the head, breathes in the scent of the child's body with all her strength. She lets out a whimper, loosens her grip on the child, waits for the emotion to leave her, and the child waits alongside her for this emotion to pass. It's done, she has withdrawn her arms and her lips from the child's body. There are tears in her eyes, the child sees them, so he speaks, but not about her pain, he says he misses the days of the storm, the powerful waves, the rain.

4

Summer is here, undeniable. It's hot. Storms pass and break over La Manche almost every day, but after the storms the sun is scorching. It can't dispel the sadness of the beach. Nothing can anymore. Summer came too late. Anwar Sadat buried the emperor of Iran with a ceremony worthy of what he would have been entitled to had he been at the height of his glory, reigning and pure. Because during the war of '73 that same emperor did a favor for the Egyptian people. Sadat had said: I will never forget. He did not forget. Sadat led the Iranian emperor's funeral alone on the world stage. At his side was that "crook" Nixon. I would happily swap Watergate, just another electoral fraud, for this gesture of going to Cairo. He went because if during the good times America went to Persepolis, in the dark times America had to go to Cairo, too. There was no doubt about it, they had to go to Cairo as they had gone to Persepolis when the emperor's crimes were already known. This lack of loyalty is much worse for Carter than being compromised by his brother, and much worse for Giscard d'Estaing than the gifts from Bokassa

or the illegal trading. De Gaulle would have gone to Cairo. It must
be very rare to be at one with your function, to dare to be the same
individual before the State as before your own life. Sadat is no doubt
the only one in the world. Yes, the heat is here, at night, in the day,
at night less oppressive. Couples pass under the lights of the board-
walk, the beach is very bright, in the halos of the streetlights, almost
white, the brightness of the night is almost as intense as where I was
born, and near Le Havre the deserted quays also serve as the cus-
toms area for the Siam border checkpoints. The entire city is ex-
posed to the heat. There's no wind at all, not even on the shore. The
sea is low, far, we can see the flat expanse of the sand, we barely hear
the panting fallout of the waves, in the silence as it approaches, its
breath. I watch. And as I watch the beach transports me to the
scorching reading of a book from my past. This reading comes to a
close, it's a painful wound, even now, almost unbearable. Always
that straight file of oil tankers in line with Antifer. Between them
and us is the Baie de la Seine, there are many fishing boats, we hear
the sound of motors and the churning water, the laughs and the
calls of the fishermen of the Ganges. The couples walk up and down,
they all look toward the sea, toward the port of the bay. Sometimes
they leave the boardwalk, they head toward the sands of the ebbing
tide, they disappear from our sight, the boardwalk remains visible
beneath the light. The book, once more, that burn in reading the
book. I see the pages and I see the room described, the cold spring,

the windows opened onto a park, an avenue, the slipping shadows, blue, of the night, they enter the room, and I see them stare at each other endlessly without being able to tear their eyes away from each other, not a single movement although they have never touched, not a single word although they have never said that they love each other, I see them locked away in that Vienna house after the death of their father, for months, I see that they are brother and sister, that their gait, their eyes are the same, their bodies, that they are careful in town so that no one will know, and I see that nothing will ever happen, nothing, to allow this love to die at last. The book is not finished. The end was not written, it was never found. It would never have been found. The fatal end of the book did not exist, does not exist. The torture is endless. The end is on every page of the book. The author is dead. The book is here suddenly, frighteningly isolated, eternalized in the brutality of its suspension. Then it closes again. On the boardwalk, long and dark, so slender she looks like a shadow, the young counselor from the beach passes. She is with the child. He walks slightly off to her side, they move slowly, she speaks to him, she tells him that she loves him, that she loves a child. She tells him to listen to what she says like a story that isn't meant for him, or else to listen to it however he wants, she tells him her age, eighteen, and her name. He repeats her name. He is slender, thin, they too have the same body, the same gait, a little lethargic, de-layed. Under the streetlight she stops, she takes his face in her hand

and she lifts it toward the light, to see his eyes she says, those immeasurably gray eyes. She lets go of his face, she speaks to him again, she tells him that he will remember for all his life this summer night and her. She tells him that when he's eighteen years old, if he remembers the hour and the date, midnight on July 30th, he can come, she'll be there. She tells him to take a good look around, this night, the stars, the sea, the city over there, all these fishing boats, these sounds, listen, that it's the summer of his sixth year. And they walk toward the sea, until they disappear in the sand, until the horror. Until they return through the tennis courts. She carries him on her shoulders. She sings. Resting against the body of the young girl he has fallen asleep. They leave the boardwalk and disappear into the hills. Once they're gone it is fully night. And the day comes early to snatch away sleep. The day is bright, crystalline, it rained during the night. The Olympics end like a bloody masquerade, Intervilles, the final grand parade—Broadway, minus the majorettes—showcases the infinite richness of human flesh. The graphic images of the Olympics closing ceremony evoke the Mussolinian and Hitlerian ensembles of the 1936 Olympics in Munich, the human mass is already equal to that of the death toll of the war, the gulags. In a few years we'll understand that in August '80 we lived the Munich of September '38. The Moscow Olympics sanctified the handover of Afghanistan to the Soviets just as the meeting in Munich forced the Czechs to give the Province of the Sudetenland to Hitler. Similarly,

the resemblance is decidedly atrocious, it sanctified the Anschluss of March '38 and the murder of Schuschnigg. The Moscow games also represent the endorsement of the Olympics, this occupation by the Olympics of televised space, which has just allowed Soviet Russia, amidst a media frenzy around the withdrawal of its troops and tanks from Eastern Germany, to replace them with other tanks, more numerous and more modern, a thousand tanks of the latest model, not only in Eastern Germany but also in Poland and Czechoslovakia. It's hard not to think that Europe is engaging in something like compliance to the criminal solution of history, a means to an end. For it is not the government personnel who would impede the Soviets were they to arrive in Paris tomorrow, on the contrary, they constitute a good, well-managed base of senior civil servants, an economy of civil servants. Valets. Remember Nazi Germany. For our governors and their best accomplices, the French Communist Party, the end of the world is the atomic bomb. For us, it's not the atomic bomb. For us, it's the prosperous and definitive reign of Soviet Russia over the European continent. For them, that is a lot less serious than dying. For us, no. Shouldn't we tell them, that we don't see it this way? So, says the young counselor, let's get back to the tropical island. Ratekétaboum drops David off on one of the island's beaches. This is the island of the spring, he says. Thank you, says David. Oh dear, says the shark, I'm hungry again, he looks at David eagerly, he says that seeing him so fresh, so well nourished, alas. He

says that he would even be capable of, yes, that's what he means to say, that his existence is atrocious, a calamity, that he eats his own weight in food every day, that he doesn't have enough life to keep himself alive, that he ends up swallowing his own friends without realizing it and so on and so forth, he speaks without David being able to do anything to calm him down, and David realizes that the shark is falling into a terrible depression, and that it would be best to let him fall all the way into it, and so he distances himself and plays a little harmonica that he has found in his pocket, but now the shark, hearing it, cries even harder because the song is about a very pretty and very sweet woman who has a fiancé who left, what a shame, out to sea, and then he starts to speak very loudly, very noisily, with abnormal speed and any which way, a language made up of grunts, of nothing, incredible exclamations, rattling of teeth, and also crying, so finally David tells him to calm down, that he doesn't understand what the shark is talking about, and the shark calms down right away, he apologizes for having let himself fall into despair but says that it's the last time, then he says that, actually, to sum up, what he said was all he had to say, not a word more, and that's that, without at all saying what he said, and then he says that he understands, who knows what, and that he will leave for Guatemala, a bit of warm sea in the winter, it's good for chronic bronchitis, and that's that. David asks the shark whether his mind might be a bit deranged and the shark says yes, just a little bit, he thanks him

but it's nothing serious, so they part ways, they wish each other a good stay and a good journey. Afterwards, David climbs to the top of a coconut tree, he ties his red bathing suit to a branch to signal to passing boats that a child is there. And then he lies down, he realizes he has become a little child lost in the middle of the ocean, that a new life is beginning, and he falls asleep in his new perdition, he wakes up, looks around him, goes to sleep again, wakes up again, and it goes on like this for a while, back and forth. The young counselor tells of David's distress on the island in great detail, she looks away from the children and begins to recount something slightly removed from the story of David, she says that David has gray eyes, that he does not speak, that his hair smells like the air after it has swept along the sea. She says that David will grow up and that this is something that makes her want to die. The child who keeps quiet is seated next to her. They don't look at each other. As for the other children, they are so quiet and content with the young counselor that they listen to everything she says, even about David's distress. Yes, so David sleeps, wakes up, sleeps, wakes up again and then one night, one day, one day's night, something happens to David. That night, the sky is orange and gold on one side, the color of David's eyes on the other, and the sea, the sea is the color of the night, thickened with a deep black, you know, you see what I mean? Yes, they see the night she describes. But the young counselor lies down on the sand and she

says that she's tired. So the children yell, they hit her, they call her nasty and mean and she, she just laughs. Come on, tell us the story or we'll kill you. But she laughs and she falls asleep laughing and the children all go for a swim in the sea.

5

The tide is high, water slack, the surface of the sea is smooth, perfect, silken under a heavy and gray sky. For a few days now the storms have been drifting away and fleeing seaward. It won't rain here today but out on the open sea. Ten o'clock in the morning. Here, the weather will be nice. You can already tell because of the slight offshore wind, this brightness devoid of shadows that spreads out in great uneven patches over the sea, and this light, at times yellow, that colors the sand, the town. In the distance, the black channel of Antifer. This morning, there's also a large white cargo ship. Hunger has once again struck Africa, this time Uganda. The television showed images of Uganda. The television always very faithfully shows images of hunger. Crews leave here to photograph it, and that's how we see it in action. I think it's better to see it than to hear about it. Thus we see Uganda, we see ourselves in Uganda, we see ourselves in hunger. Of course, they are already deep into the voyage of hunger but we can still recognize them, we are familiar with this kind of data, we've seen Vietnam, the Nazi camps, I saw it in my

room in Paris during seventeen days of agony. This time around, they are even further ahead than the others in Earth's final voyage toward its definitive sterility, the gradual effacing of the membrane of life that covers it. We know that it will begin with the depletion of water, then of plants, animals, and that it will end with the sweet and tender despair of what's left of humanity, a thing I call happiness. Already, they resemble one another. Here the body is the width of a board, a hand. The tears have disappeared. The fear has disappeared. The laughter. The despair of thought. We watch them passionately. This is us, this final form of man, his final state. They are nothing more than the acute awareness of what's happening within them, as if they were still in the stage of infancy, the infancy of death, without a voice. Like the child who watches, they die. Most of them can still walk, very slowly, of course, but they're able to move their bodies toward the vitamin-mush distribution points and the fountains. They can park themselves in the shade, some of them manage it. The temperature has reached the fatal hundred degrees of hunger zones. Family ties are no longer visible. The women still hold the babies in their arms but the children who can walk are independent. Like the deported, they resemble one another, they bear a surprising likeness. In their bags of skin are the same skeletons, the same hands, the same faces, no longer anything more than this final residue in its most advanced abstraction: life. There are no more infants, no more elders, no more ages, all their gazes are the

same, lacking focus, resting on the camera as on the ground. They are men of clay, those of the first deserts, those of the last deserts. The loop closes once more. Heterogeneous, without any distinctive qualities, agglomerated to one another, these are the men of the Terrasses de Lorraine, those of the dry Lascaux years, perhaps also of Golan, the banks of the Sea of Galilee, who wait together for the fertile rains, the return of the herds of deer, the manna of the Gods. They're naked. Their only possession is a mess kit, a can or fractured vessel likely containing liquid mush, water. I think nothing faced with Uganda. Just as, back from the concentration camps, I thought nothing. If I think something, I don't know what it is, I'm incapable of uttering it. I see. I avoid those people who, upon learning these things or seeing them already, know how to think, and what to think, and what to say, and what conclusion to draw. You should be wary of these people, for they want above all to forget this very knowledge, to distance it from themselves by turning to its immediate solution, you should avoid those people who speak of remedies and causes, who speak of music within music, who, as a Cello Suite is being played, talk about Bach, who, as God is being discussed, talk about religion. The child remains. He is there. A night passed through the gray and shifting weather. This morning the sky has a blue varnish, the sun is still behind the hills. The child passed by along the boardwalk. There was almost no one on the beach, a few stragglers, they turned their backs on the child walking by. As

he walks he plays with a marble that he throws in the air and then catches. I watch him until he disappears around the beach bar-tabac. Then I close my eyes to re-encounter within me the immensity of that gray gaze. I re-encounter it. It's a gaze that overlooks everything it beholds and each time gets lost. You can already hear the rest of the summer campers hurtling down the hill. As they come down they're still singing the same song, no one can understand a word of it. The young counselor stops on the boardwalk and watches the child return. She goes to him. He gives her the postcard he has just bought at the store and she puts it in her beach bag. They don't speak to one another. The whole camp goes swimming. In the sea, as in sleep, I can't distinguish the child from the other children. I see him when she goes to him. She takes him on her shoulders and they advance into the sea as if to die together, in the distance. Then, as they return, she has him swim alongside her, slowly. There they are. They emerge from the sea. He has the body of a white Ugandan. She dries his body. Then she leaves him. She returns to the sea. He watches her. The sun rises from the hills and floods the beach, the sea, the child. She's still walking, in the distance, at low tide you have to walk far to reach the deep water. She's reached it. She enters it, turns around, blows a kiss to the child and then moves toward the open ocean, lowered into the sea. He keeps watching her, motionless. It's easy to follow her on the flat surface. Around her, the sea has been forgotten by the wind, abandoned by its own power, it

possesses the grace of a deep-sleeping beauty. The child has lain down. And now once more the sky becomes slightly overcast, always these clouds passing through. Habit forms out of this inconstant sky, out of this road for the winds guiding the rain and the loess to Chinese shores. Around the child the world spins, this entire day here contained in his eyes. The young girl has returned, her body is now splayed out near the child's. They keep quiet, eyes closed, for a long time. On the other side of the world, the sea, the same one, carried away by a hundred-and-fifty-mile-per-hour wind, unleashes the power of the Hiroshima bomb every four seconds. Over there they call it Hurricane Allen. No human invention will ever manage to bring its power to heel or even soften it. We learn that actually it shouldn't be meddled with, that this power is good for the life of the oceans, of the earth, the nourishment of its rainfall, of its currents, the aeration of its waters, that this power ensures the regulation of the earth's energy, its seasons, its climates. Before Allen, facing it, these bodies before me, the young girl's and the child's. Bologna, yes. I don't think there's anything to say about Bologna. Whether the attack comes from the Left or the Right, it makes absolutely no difference to me. A friend writes to me that "the extremists on the Left lash out at minorities and what the Fascists always seek to punish is in fact the people, especially if they are lucid and free." It's possible. I couldn't care less. I can see that it's the same people who commit these crimes, that from the start they all

have this same deep, relentless appetite for killing. That it's after quenching their thirst for killing that they engage in more obvious discrimination, because of their love of facades they come up with acronyms, shady business names found in old comic books. The police should of course take a look within their own community to see what the real endorsements are, they should also take a look behind the scenes of politics, that realm said to be above suspicion, where money is given to crime rings for apartment leases, luxury cars, weapons, bribes, champagne after the mostra in Bologna. But we know the police won't ever do this, ever. So one should not listen to the heads of state, one should not read the newspapers when they explain the various terrorist workings. It's a lost cause. In Iran people are killed so often that it's boring. Iran bores the entire world to death. The child remains. On that night, recounts the young camp counselor, David hears something on the island. It's not a tree splitting, or a stone falling, it's a living sound. It's on the island. David searches, it's a sound David knows but he's forgotten the word, and the young counselor says she too has forgotten it, she looks at the child who says it with a slight squint of his eyes. He says: Crying. Yes. That's the word. Something is crying on the island but without begging for anything, without screaming, without anger, without even being aware that it's crying, perhaps while sleeping, as one breathes. David wants to know who it is. He turns around. He sees a marvelous thing, there among the trees, lying down, spread over

the side of the hill, in the golden light, the entire herd of all the island's animals. A large stain, wild, white, black, pierced by the diamonds of eyes watching David. They have the same tender and horrified look as David. I'm lost, cries David, I'm a child, don't be afraid of me. Fear disappears from their eyes. Who's crying? asks David. The spring, say the animals. Every evening when the sun goes down the spring cries. The spring comes from Guatemala, she's crossed many oceans to get here, twenty-two of those underwater countries, she's very old, she's seven hundred million years old, she yearns for death. They go quiet. I feel like she's listening, says David. She is listening, say the animals. She doesn't always think about death, say the animals, sometimes she forgets. They go quiet once more. Something calls out. It's the spring, say the animals. The spring asks who's there, she says that for a little while now something has been walking around, an animal she doesn't recognize. It's a child, answer the animals. A man's little one? That's right. The spring goes quiet. Then she continues: Does he have hands, this child? The child shows his hands to the animals, who answer yes. They all approach the child and look at his hands. David shows them how he uses them, he picks up a stone, throws it in the air, catches it, he plays the harmonica. The animals tell the spring what they see. Does he know how to kill? asks the spring. David says no. A long while passes and, as the sun drowns in the sea and a great calm spreads all around, an enormous rushing of water can be heard. The spring is leaving the

Atlantic basin, say the animals, there she is. The spring leaves the hill. She's a giant, a mountain of water, she's glassy like a heap of emeralds. She has no arms, no face. She's blind. She moves very very slowly so as not to unravel the many waters she wears around her, wrapped around her body. She cries. She seeks David's hands. The animals surround her and protect her from David. A final gleam from the setting sun enters her dead eyes. And then the night fully arrives. David, David. She seeks David in order to die. Some light escapes from the mountain of water and illuminates the hill. She cries. She calls out to death. David. David. She's like a slow wave rising from the sea. David, David. David takes out his little harmonica and plays a very old song from Guatemala. The spring stops moving, dumbfounded at first and then, little by little, with an infinite slowness, she moves. And look, look, look how she dances and starts to forget death. She danced until daylight, says the young girl, and when the day arrived and dove into her dead eyes, the animals of the island brought her back to her bed, the dark cave of the Atlantic basin. The young counselor goes quiet. The children move away. She cries. The child lies near her and keeps quiet.

6

First off, apparently, nothing new has happened these days, nothing but the passage of time, murder, and hunger, and Iran, Afghanistan, and then, gradually, something new emerges from the stream of days, it happens a very long way from us, far away, in Poland, the peaceful strike of the shipyard workers in Gdańsk. We know the numbers, their ranks have grown from seventeen thousand to thirty thousand, and that it started seven weeks ago. That's all we know. Here, near me, on either side of the Touques this August 15th, the population will reach close to a million. At the height of tennis season, of beach cabanas, it will reach the density of the population of Calcutta. Still this perfect weather, this flat sea, pale blue, darker in places. A storm clouds the bright colors and lines but it passes quickly and once more the blue returns, along with the thousand-year-old flatness of the sea. Before, when the sea would sleep like this beneath the empty sky, men were afraid. In those moments, the infinity of the world was within reach, in the animals, the forests, the earth itself infinite in that moment, the sea. Nothing had a defi-

nite form yet, it seemed obvious that nothing would ever have one, and already men sensed that the world was old. That the sea's sleep was proof of this. Just as their own dreams were proof of this. The present has always had to be lived in this way by men, as if it were the obvious moment when the world would end. The tragedy is here, here where we are, and before us, nobody had heard of fear. The opacity of the future has always disturbed our fragile and aching heads, that poignant failure of a divine order. It's the opacity of tomorrow that drove man to the Gods and that still drives him body and soul toward the cult of that organ of the State. Without his fear, man would face the unknowable of his life alone and without aid. But did man exist only once, for one day? No. Every civilization has claimed the privilege of knowing this fundamental opacity. And all have abused it. The State is the institution of that abuse. We view history as we view our childhoods, our parents, as having no purpose other than our own advent. For us, the living, history's duration has always been illusory, it has had no meaning other than that which we ascribed to it, other than its connection to us, to our bodies, to the absolute purpose that we possess in our own eyes. Judaism alone can experience History as a time without a future, without a plan, at a standstill, with no illusions of progress, of eternity, of significance. Nearby, this crowded beach, the sun's revolution in the circle of the sky. And the child too. Gdańsk makes me tremble like the child makes me tremble. The child passed by. Then the

summer campers. The young girl was not among the group of coun-
selors. She arrived later, carrying the bread for lunch. The camp dis-
solved into the mass of people on the beach. As the morning went
on the weather became as sharp, as gleaming, as flint. In the Port of
Antifer, twenty-one boats await the twenty feet of water at high tide.
The city has been inaccessible since last night. Impossible to enter.
It's completely crammed with cars driving around on the lookout
for a parking spot near the beach. There's no more parking. There's
a half-hour line to buy a slice of ham. All the stores are open. There
are no more opening and closing hours, the restaurants serve food
all day long. Here, this national holiday, August 15th, is also the
celebration of a Sunday that has been replaced by all the other days
of the year. These cars that circle at twenty-five miles per hour,
packed with children, sleeping bags on the roof, grocery bags tan-
gled up with the children, they end up leaving the cars where they
are, come on let's go, they run to the beach. The police scream into
the loudspeakers the license plate numbers of the cars obstructing
the roads to Paris, Caen, Honfleur. I don't go out, I don't read, I
don't do anything but watch the day go by, sleep, incapable of work-
ing. I know that the telephones no longer work in Gdańsk, that
people can no longer go there, the Polish airlines tell those asking
for tickets that they're sold out. The summer campers left with the
midday sun, without singing. Today they are obedient, as if chased
from the beach, intimidated. Their happiest days were the gloomy

and vast days of rain. After the campers have passed, the young girl and the child arrive, far behind, always very slowly. She has her hand on the child's neck, she speaks to him. He walks with his head slightly raised toward her, he listens to her attentively, sometimes he smiles. She tells him about the shark Ratekétaboum's visits to David, how one time he shows up with an American accent, another time with a Spanish accent, another time with an accent of nothing at all, a sneezing, nose-blowing, blushing accent, and David has to put up with it because people put up with everything, people put up with everything, he laughs for no apparent reason, he spews nonsense in every direction, in order, in disorder, he makes no sense at all, one time he says that he saw a little girl who was crying because she had lost her ball in the sea, and he cries, another time he talks about war, and he laughs, and another time he's seen nothing at all and he shrieks with laughter, another time he shows up with a baseball cap that he found in the sewers of New York when he went to listen to rock music who knows where. So in the end David asks him if all sharks are like him, as eccentric as him, Ratekétaboum, but the shark doesn't understand the word eccentric, he starts to shout at David that he can't understand how he, David, can't understand how a shark might not understand every word, and he starts to yell more, louder and louder, faster and faster, and monsieur, I thought I told you that I am nothing but a poor shark, I beg you to speak to me in more simple language, and also it was finished be-

tween the two of them, etc. So David leaves. And Ratekétaboum calms down immediately and asks him to come back. So go the shark's visits. All of that, and, on top of it, the shark's desire to eat David every time and his crying and, etc. And so on. And time passes, says the young girl, and David grows older. The child waits, the young girl has stopped talking, so he asks her if the spring still dances in the evening. Yes, she says, every evening until nightfall, and not always the Guatemalan polka, sometimes to an Argentine tango by Carlos Alessio. The child makes an effort again, always this struggle to speak, to chime in, he asks how long David stayed on the island. The young girl says that he stayed there two years. She waits. The child doesn't ask anything more. So she asks him if he wants to know the end of the story. He shakes his head no, he doesn't want to know. They keep quiet for a long time. They walk like strangers through the city, alone. The young girl asks the child another question, she asks him what he would have preferred, that David kill the spring or leave her alive. The child stops and looks at her, she has also stopped in front of him. He hadn't thought about it, he thinks about it. The response is slow to come, he hesitates, his eyes seek those of the young girl, and then he speaks: That he kill the spring. His eyes remain fixed on hers, he waits perhaps for her to say something, but no, she pulls her eyes from his. They keep quiet for another long moment. Then the child asks a final time: And you? She says that she doesn't know. He has nestled himself against her and

they walk to the stairs of the Black Rocks without speaking. They disappear behind the hills. On the other side of the window, night has fallen, it's very dark. The television works. I watched the news in disgust, I left it on. I hear the panting and frantic voices of the hosts of *Jeux Sans Frontières*, as if they were horrified at not making people laugh enough, it's almost unbearable but I leave the television on until it's over. I let the entire program run, I didn't see a single image. It happens to me quite often. I left Trouville yesterday afternoon, I'm in the countryside, I do nothing. An editor at *Libération* calls to see what progress I've made, I say that I've done nothing because I'm anxious about Gdańsk. He tells me to write anyway, even about that, about knowing I can't write because of Gdańsk. I say that I'll try. I stare at the blank pages for a long time and then I lock up the house, I go up into my bedroom and once again I'm in front of the blank pages of the strike in Gdańsk. Uganda, everyone can see it. Gdańsk, no, hardly anyone can see what Gdańsk is. Suddenly the truth rings out: hardly anyone is capable yet of feeling the joy of what's happening in Gdańsk. I am alone, and in this joy. I am in a solitude that I recognize, distinguishable from all other kinds of solitude, there's no cure now, it's irremediable: political solitude. It's this joy I cannot express to anyone that keeps me from writing. That's what it is. I try to call some old friends, no one's there, no one's anywhere. People can't comprehend the joy of Gdańsk because it's revolutionary in nature and people are no longer capable of rev-

olutionary thought. I dial the operator, I ask for the exact name of the Polish airline company. A young man answers almost immediately: Polish Airlines, he gives me the address and the telephone number. He tells me: You won't be able to get a seat on any plane to Gdańsk, they don't want anyone to go and see it. We talk for a few minutes. He supports the strike but he thinks it'll fail. I say that it'll probably fail, yes, that the demands are too extreme, finally I'm speaking about Gdańsk with someone, so extreme, does he know what they are? Not really. It's one in the morning, he feels like talking too. I tell him: They want everything, they won't give in on anything, they want things that would never be granted to them anywhere, not even in the richest of countries. He asks me: But who are you, a journalist? I say no, nothing, that I just wanted to speak about Gdańsk with someone. Ah, so that was it. I say yes. He says that it happens often, at night, people who just want to talk but not usually about politics, usually about their lives. I say that I feel that way too sometimes. He asks me if I'm afraid for Gdańsk. I hesitate and say no, I don't say that the success or the failure of the strike in Gdańsk makes no difference to me. I say that I'm happy it happened, and what about him? He says that he's not well enough informed, that he doesn't know. I start to write the article for *Libération*.

7

One year ago, I sent you the letters from Aurélia Steiner. I wrote to you from here about Melbourne, Vancouver, Paris. From here, above the sea, from this bedroom that now looks like you. Tonight, I see you again, you whom I didn't know, probably because of the news from Poland and because of the hunger that abandons me, yes, you see, that abandons me to myself. This bedroom could have been the place where we loved each other, so that's what it is, the place of our love. I have to tell you at least once, when it comes to you and me I can't be wrong. I sent you the letters from Aurélia Steiner, from her, written by me, and you called me to tell me about the love you felt for her, Aurélia. Afterwards, I wrote other letters to hear you talk about her, about me harboring her and delivering her to you as I would have delivered myself in the murderous madness that would have united us. I gave you Aurélia. I wrote to you then for you to feel the effect of Aurélia emerging, you, so that you would be there between me and her in that very moment, so that you would be almost the very reason, you see, just as, in the same way,

you could have been the very reason I would have never written a thing about it if for example we had loved each other and so much so that Aurélia's words would not have come to life, but only ours, those of our names. You are thus the reason for the existence and the non-existence of Aurélia Steiner in me. I offer up to you once more this night, without a name, without a shape. Just as I offer you Gdańsk. Just as I offered you the Jewish continents, and Aurélia, just as I would have given you my own body, I give you Gdańsk. Like with Aurélia, I cannot keep Gdańsk to myself, as I write Aurélia I write the words of Gdańsk, and like with Aurélia I must address Gdańsk to you as it emerges from me. Here she is between us, contained between our bodies. Look at her. She's radiant like desire, she emerges from the depths of the darkness, she is ours. Look at how our spirits shatter when confronted with the widespread death, murder, of the proletariat, how close death is to us, how close it has always been to us, as close as life itself. Everyone is sad because of Gdańsk, except us. The pain that we once had now shines a whole new light on today's politics. Like a beacon shining a light on the vast putrid landfill of European socialism. The others can stay silent. Gdańsk is us. And it's reality. And faith in God merges with this reality, this forbidden practice of God is precisely this reality, what's not real is their theory forbidding the so-called unreality of God. The sadness of the military is inevitable. For, you see, the joy of Gdańsk can only be known in one place, the place uncontaminated by power.

It's impossible to know that joy if one has even an ounce of power to manage, to preserve. With Gdańsk, they wanted to kill us, kill the common good and also, above all, the good of each individual. I see you, we laugh. Today, the wind came with the evening, no gusts, you see, constant, cold. It chased away the people, the birds, the colors. It was six o'clock at night. The light was already dimming, the sea was gray beneath the faded and empty sky, as if it were already getting to work, already foreign to us, yes, already in action, creating wind, the cold. Over by Antifer, the sky was clear, the horizon flawless. And the sudden wind that took over, and the cold. Some people said, the first to dare: Summer's already coming to an end. The windows of the hotel closed onto the sea, and the lights went out early. The best thing, in this situation, is to sleep, caught between the difficulty of imagining and the repugnance of knowing. There was no one on the boardwalk, only the wind, no one on the beach either. During the hot nights, and there were many here this August, there were always people strolling on the boardwalk, and some couples on the beach, they would lose their way in the terrifying realm of the territory of the sea. That night, no. Just as no one was writing in the hotel, no one in the city, nowhere, except me. The two typewriters, always the same ones, in the summer, in the hotel, no one could hear them. And the wind blew in around two in the morning. In surges, always, a sudden rushing, and then it would totally disappear, vanish. From the balcony I saw the air had become

still again and the sea had gone back to sleep. I thought to myself that they would never have Gdańsk, ever, no matter what happened down the line. Never. That it was us who had it. And us alone. That they were excluded from it. And that their sadness was also in part their suspicion of our joy. The night was resounding and hollowed out by the absence of eyes on its obscure splendor. We heard what sounded like its grain, its step. I was there for that, to see what the others still did not know, to see that night among nights, that one like any other, as bleak as eternity, containing all that is unbearable in the world. I thought of the concomitance of the child and the sea, of their similar, captivating difference. I thought to myself that we are always writing on the dead body of the world and, similarly, on the dead body of love. That it's in these states of absence that writing rushes in, not to replace what was lived or believed to have been lived, but to record the desert that's left behind. The calm of the night followed the wind but this calm had not been created by the wind's retreat, it was something else, it was also the coming morning. The doors of Aurélia Steiner's house are open to everything, to hurricanes, to all the sailors of the ports, and yet nothing happens in Aurélia's house but the desert of writing, the continuous recording of that very fact, that desert. I mean the complete mourning of the Jews taken on by her like her own name. Those people talking about Montaigne on television, did you hear them? They said that Montaigne had left the Parliament of Bordeaux, his friends, his

wife, his children, prematurely, in order to write. He wanted to re-flect, they said, and write about morality and religion. I don't see any such decision in Montaigne's retreat, rather than seeing it as logical I see it as steeped in madness and passion. Montaigne took up writing to go on living after the death of La Boétie. It has nothing to do with morality. And if, as Michel Beaujour used to say, the only one to have dared, his "Essays" are not entirely legible and no one has ever read them in their entirety, just like the Bible, even less so perhaps, it's because neither work ever exceeds the singularity of a particular relationship, which is eternalized by death in the "Es-says," by faith in the Bible. If Montaigne had written about his pain, it would have conveyed all the writing of the world. But he only writes as if in order not to write, not to betray, precisely by writing. By doing so he leaves us without him, enthralled, satisfied, but never accompanying him in his liberty. You know, this morning, the weather was once again resplendent, the beaches were covered again with kites, with children, with families worn out by life, al-ways sad, you see? Always. The summer campers walked right through it all, they were singing this morning, always that indeci-pherable song. And as always there were other children who fol-lowed them, because nothing, at first glance, distinguishes them from the orphans and the orphans, just like lost children, exert over the children bestowed with family and love the incomparable ap-peal of abandonment. Yes, the child with gray eyes was there. Close

to him, the young girl. From time to time he would collect things on the beach and she would wait for him. And the other counselors gathered all the children, always ahead of those two, and she said to them: We're going to sing. The child with gray eyes sat down near the young girl. And everyone sang, except for the child and the young girl. The counselors asked the child to sing with the others and he didn't answer. And the young girl said it was because he couldn't sing with the others. They couldn't understand what the young girl was saying. And they wanted for the child to answer. Why don't you want to sing? And so the child looked at these people who were interrogating him, then at the other children, as if he were waking up suddenly, not timid, but with a slightly frightened amazement, and still with a slight tension in his face, the threatening sound of the words shattered the stillness of his features, and he said: I don't want to sing. They hesitated, they said that the young girl was overly protective of the child. She replied that she wasn't protecting him. They told her that the peculiarities of a child should never be encouraged but instead measured against the status quo, that she should know that. The young girl replied that she didn't understand what they were saying. They told her to go off with the child, if he was so different from his peers. So they took off, you see, from the other side of the pier, toward the clay hills and the black boulders. And there, she sang to the child that she had taken a walk around the clear fountain, that on the highest branch a nightingale

was singing and that she would never forget it, and the child listened to the words. The sea was receding and there, between the hills and the sea, is a stretch of flat sand, a large stripe that retains water and sparkles like a mirror for a certain amount of time each day. And the young girl spoke to the child, as they were walking across the mirror, about something she had read recently, something still burning, that she couldn't shake off. About a love, she said, that awaited death without provoking it, infinitely more violent than if they had they acted on their desire.

8

It was overcast and the storm came in carried by the north wind. This wind was very strong, indivisible, relentless, a wall, smooth and straight. And the sea broke loose once more. There was some rain in the night that was chased off by the force of the wind. All night long that wind howled, beneath the doors, through the cracks of the walls, in our heads, the valleys, our hearts, our sleep. The bedroom I'm writing to you from was also gripped the entire night by the somber and massive roar of the sea. Within its waters terrible motion was underway, crashes, crevices filled back up the moment they opened, the violence dissolved as soon as the surface was breached, as if nothing had happened, in an enormous white surge. People started to talk, they were afraid, they said: That's the sound of the convoys, the sound of the war. In the moans of the wind they saw signs of the East, those signs of death, you know how they are, how we are, how troubled our spirits are, how we abandon all reason, how we are always ready to return to the black cave of our fear of wolves. But no, it was nothing, nothing but the sounds of the sea

and the wind. And see, the sun rose over the world. The sky was naked and white but the sea was still raging. It remained that way for a long time, in that state, you know, that absurd and vain nocturnal state, insomniac and old. It struggled for a long time in the daylight that illuminated it, as if it were the sea's duty to carry out this foolish destruction of its own waters, prey to itself, prey to its inconceivable magnitude. From the dawn of time, the sea has carried white armfuls of its anger to the beach, brought them there as if it were settling a debt, as a beast does with bones, as the past does with the ashes of the dead. Yes, the child with gray eyes was there, and the young girl too, they were looking at the sea. And I brought them back to me as I do with you, with the sea and the wind, and I shut you all in that bedroom lost above time. It was the middle of the day on that Saturday in August when the news arrived. Yes, Gdańsk. Accepted. It had been signed. Like you, I called people, they had heard the news, the same news, and now there was no possible doubt, it had happened. I don't know how to talk to you about this news. Everyone talks about it thinking they're being clear and suddenly that clarity distances me from them, so great is it, so judicious, so logical, so convincing, it brings me back to Gdańsk as though to a homeland of silence. Because I believe that Gdańsk is a silence built on the indefinable crux of what tried to be defined, of what was pulverized, crumbled, separated, yes, it's words as they incubate, separated from speech. I think that Gdańsk is above all

about silence, silence is the vessel containing all of Gdańsk, its miraculous novelty. I had spoken in detail about each of the demands of Gdańsk and I've just thrown out what I had written. Gdańsk is already in the future. And even if it fails and is massacred and its blood is spilled, it can't be undone, it's monolithic and at the same time accessible to all, to absolutely anyone watching. The demands of Gdańsk are in such synchronicity with the fundamental demands of mankind that they are reinvigorated with what seems to be new-found knowledge but, in the same way as Gdańsk, they are indissoluble, and clear. The lightning is in the consciousness, it is no longer in the forest. We thought there was nothing more to learn. And now we know what we thought we didn't know. Because to see Gdańsk is to know that. Let's try to approach that disarmed army, calm and alone, the army of History. Let's try to approach it in the only way possible, by avoiding the gibberish of theory, I'm talking about the imaginary. I talk to myself as if it were possible to talk to them, and I answer myself as if it were possible for them to answer me. And all of this is made up, and all of it can be refuted, both its syntax and its vocabulary. Did you have the right to ask for better salaries? No, they would slaughter us. Did you have the right to write what you wanted? No. To read what you wanted? No. Did you have the right to defend yourselves? No, there were organizations created for that, too. Did you have the right to believe in God? No. Were you hungry? No, we ate our fill. Did you have the right to join

a league in defense of the Rights of Man like the one in Helsinki? No, it was forbidden. Did you have access to the grocery stores reserved for those in power? No. Did you have the right to buy an automobile? Yes, but we couldn't buy one with dollars from the black market, we were paid in złoty. Was the delivery time long? It was two years with złoty and eight days with dollars. Did all of the leaders of the Communist Party have cars? Almost all of them. But you were still freed from capitalism? Those are just words. The exploitation of man is worse in socialist countries than anywhere else. But you ate? Yes, we've been eating for sixty years, since 1917. Is there no capitalism in socialism? Yes, there is, the whole nation is a black market. What's the difference between capitalism and socialism in this case? Capitalism has no justification, socialism does. Who are these people of the Party? We don't know, it doesn't matter to us. Do you have an opinion on them? No, we don't care about them. How do you explain that they're still recruiting people in Poland and elsewhere? It must be to these people's advantage, or else they don't know anything about politics anymore, who knows, we don't know, it doesn't matter to us. Do you listen to their speeches? No. Can they teach you anything? No. Can they teach you something about themselves? They can't teach us anything about themselves either. Are there differences between one member of the Communist Party and another member of the Communist Party, are there good members, bad members, liars, non-liars? No. As

long as they remain enlisted in the Communist Party, there are no differences between them. How would you define them? Through fear. How have you accepted the intolerable aspects of your life, for decades and decades? Through fear. Three times we tried, three times they killed us. The same fear as that of your leaders? Yes, the same, the fear of dying or of being imprisoned. Has that fear dissipated now? No, it's still there. Is there a difference between your leaders' fear and your own? None. But you eat your fill every day? We had to wait for hours to buy food, but we ate, yes. What's new about the strike of the workers in Gdańsk? Determination. Does Gdańsk mark the limit of what you were able to tolerate? No. It shows just how determined we are, the strike was planned and the date had been set: summer '80. Would you call the strike political? It's a strike that concerns all of Polish society, the Polish nation, if it represents a reworking of the structure of socialism that makes no difference to us, they can interpret it as they like. The law, what is it? Nothing, it's like bureaucracy, they want to justify their privileges. You called on intellectuals to represent you before the Party, why? First, because they have always supported us, second, because they share the same political culture as the writers of the party, it was a question of language, there was no point in us going. The bourgeoisie doesn't inspire confidence in you? It only exists in relation to money, it does not exist otherwise. Do you want to be in power? No. We want to take care of Poland, bring it out of its current sickness.

You rely only on yourselves? Yes, we no longer trust in anyone but ourselves. You know that what you're saying can be applied to most European countries? Yes, we know that. Do you believe that human nature is fundamentally good? No. Do you believe that evil can be minimized? Yes. The destructive force of man dedicated to evil can be diverted, repurposed. Evil is a force too. Are you pessimistic about mankind? Yes. Do you believe that optimism, one of the fundamental principles of socialism, is also the most idiotic? Yes, I believe that. What are we saying by saying all of this? Nothing. These are just words. But you ate like they do in China, in Russia? Yes. Tell me why you speak of hunger? Because like you I believe that in the satiating of hunger there is what we could call, if you like, the new socialist oppression of man, which is an exact counterpart to that of man's former misery. A socialist country, by definition, is a country in which hunger has vanished. The other facets of man are not mentioned. A man who eats is considered a free man, a satiated man. A satiated man no longer has anything to complain about, as long as he eats his fill. The man of socialist countries has thus found himself trapped in a definition limited to his nourishment. Society had no need for anything else but him, this well nourished man, in order to construct socialism. But, just because famine is a state of suffering and sterility doesn't mean that suppressing that suffering creates a state of happiness and fertility. The satiated state of man doesn't matter, it should be a natural state where man has access to his own

thought, to his essential solitude, to his misfortune, to his intelligence—including the nostalgia for his legendary hunger, for his failures, for his initial wandering. But, in this case, the nourished man was made into an end and the socialist victory over the hunger of mankind everywhere was made into a major justification, and so the nourished man has found himself now faced with the debt of his own life, borrowed by others in his name. The scandal became hunger, but never how it was exploited. Thus the socialist man remained a rescued man, enslaved to his past and to his family in hunger. And the state of being satiated became as much an impoverishment as the misery that preceded it. The child had never seen such a powerful storm, he had no memory of such violence and no doubt he was afraid. So the young girl took him in her arms and together they entered the foam of the waves. The child was staring at the sea, clinging onto the young girl, he was gripped with terror, he had forgotten the young girl. And in his oblivion of her the young girl saw the child's gray eyes in their full radiance, lit up by the sea. And so she closed her eyes and kept herself from advancing further into the deep foam. The child was still staring at the waves, their coming and going, the slight trembling of his body had ceased. The young girl, her face turned away from the sea, ate the child's hair, between her lips she held its salt and its scent of the wind. The child didn't know it, he now knew nothing about himself, all he knew was this chaos of the water and the tranquil resolution of its violence as

it spread over the sand. The young girl asked the child if he was cold, he said no. If he was still afraid. He hesitated and said no. He asked her if she could go farther, to where the waves broke, and she said that if she did it was likely that the force of the sea would wrest them from one another and carry him, the child, away. The child smiled. Afterwards, they took off heading north, toward the swampy meadows of the bay facing the quays of Le Havre.

9

We are approaching the September equinox, we are approaching the end of summer. The sea is unpredictable, in the night it acts out and then suddenly come morning it's calm again, it reverts back to blue and fills again with white sails and sunshine. The oil tankers are back, in a single file facing the white cliffs of Antifer. In four days, the last summer campers will leave town. The tide is low these days, the sea is very far off, from this black room I see it clearly, it leaves behind lakes, islands, archipelagos drowned in mist, entire countries of sand brimming with water. The young girl and the child walked across the bare sands and headed for the bay, near the black stakes, over by the channel. In this part of the bay, the beach is filled with silty holes and so the young girl was carrying the child again. Already the light was starting to spread across the surface of the sea, which was already more golden, more languid. They walked across the immensity of the beach, the young girl sometimes sliding and the child bursting into laughter. The stakes grew taller the closer they got. At a certain point, the young girl set the child down and

they crossed the last sandbar before the river, where the black stakes were planted. Here they are, three trees as high as flagpoles, a few yards from one another, at the edge of the river, their peaks bound with iron rings, locknuts. Now the rings have burst beneath the rust and so the trees have broken slowly from one another, freeing themselves, and after about a hundred years of this terrible iron torsion the movement is constant, the trees continue to break from one another, like in the forest before being cut down and joined together by the clamps of iron rings. The child looked at them and he asked the young girl what they used to be, she said she didn't know, that no one in the villages by the bay knew. The child waited and then he asked the young girl again, still with the same violent discretion, to tell him what they could be. And so the young girl said: Maybe an old beacon for the Seine's channel, maybe something else, with no purpose maybe, to measure the range of the equinox, forgotten markers. The three trees are not exactly the same, each has suffered the iron torsion differently, the momentum of their growth has not been modified in the same way. Their heads are sculpted with vertical grooves sliced in deep and even notches, so that the cords would better strap into the wood. The faces of the black stakes are sad, they are gifted with sight. They are turned in three different directions, toward the open sea, toward the river, toward Le Havre. These faces are gray, whitened by salt, their wood is bare, their eyes the empty holes left by the locknuts that once held the rings in place. Other-

wise the trees are dark blue, covered in mussels, at their feet is a waterhole, the sea that swirled every day for a hundred years around their resistance. The young girl laid down on the wet sand and she closed her eyes. And so the child joined the people collecting sea-shells. From time to time he returned to the young girl. The young girl knew when he was there looking at her, she opened her eyes and smiled at him, and he went off again toward the fishermen and then came back to the young girl and gave her what the fishermen had left behind, little gray crabs, shrimp, empty shells, and the young girl threw them into the waterhole at the foot of the black stakes. Then the sea little by little pearled over with green. The long line of the Antifer oil tankers became thicker, darker. It was the night coming. And the very slight muddling of the light, those gusts passing through, the rise of the mist, this wet air all of a sudden, it was the tide. And the water of the Seine was slowly invaded by that of the sea. The child made his way back to the young girl and he looked all around him with the subtle steadiness that characterized his gaze, no matter what he gazed at, a steadfast astonishment and also an intense gentleness tinted with a suffering still unfelt, still unknown to him. The young girl watched the child for a long time and she said to him: You're the child with gray eyes, that's what you are. The child saw that she had been crying in his absence. The fish-ermen left and called over to them, they said it was time to come in, that the tide was rising fast. The Seine filled with currents, whirl-

pools, it was entirely rebuffed by the smooth and soft force of the
sea now back on its course. The temperature dropped suddenly. The
young girl carried the child across the entire beach, she held him
close to her and she embraced his body. The child looked toward
the channel, perhaps he was afraid because they were now alone on
the vast stretch of sand. The young girl reached the stones ascend-
ing to the marshes of the bay. The sea never came here, she told the
child he didn't need to be afraid anymore. She put the child back
down and they walked on the path through the fields of cattail.
Then, after some time, the young girl said she would prefer that it be
like this between her and him, she said: that it be utterly impossible,
she said: that it be utterly hopeless. She said that were he older their
story would have abandoned them, that she couldn't even imagine
such a thing, and that she wanted for their story to remain this way,
forever more, in that very pain, in this very desire, in the unbear-
able torment of this very desire, even if it could lead you to take
your own life. She said that she also wished for nothing more to
happen between them when they saw each other again in twelve
years here by the sea, nothing more than this very pain, again, like
now, as terrible as it might be, as terrible as it would be, for it would
be, and that they should live it as such, crushing, terrifying, defini-
tive. She said that she wished for it to be like this until their deaths.
The child listened to the young girl with an inkling of the meaning
of her words that was more powerful than if she had tried to put it

more plainly. She told him that he would remember this path and the black trees together with these very words. That what he did not understand of what she was telling him was what she did not understand of herself before him. They arrived at the boardwalk. They didn't speak again for a long time. Then the young girl sang that she had rested by the clear fountain, and that on the highest branch a nightingale had been singing, and that she would never, never forget him. The child had never told her, but she knew, she knew that the child loved this song. When she sang it, the child's gaze lost focus and his hand in hers became lifeless. There was another way she knew it too, that other way was inextricable, indecipherable, she was the only one to perceive it, but as such, beyond herself, beyond the understanding of her own life. When they got back to the tents, people were speaking about Poland, about destruction and death. And so I returned to the night of this room above the sea and within its silence. Yes, I think we saw each other, when I opened the door I recognized you, I think that's what occurred. You left again after several days, and so, consequently, for several days afterwards, the town was darker and the room deserted, filled with the turmoil of your absence, as if shattered by this blow to its lifelong solitude. Yes, that's why I went back into the room, because they were saying they were afraid for Gdańsk, afraid of the power of arms and armies. No, I do not associate Gdańsk with the fear of it being destroyed. Nor with the power of arms and armies. Not with anything really, I

think, no, I'm mistaken, no, with myself. With you. With my love
for you, for your body. No, Gdańsk has nothing to do with the
power that could destroy it. With those people who write, who
speak, who remember. No. It also doesn't have anything to do with
its possible deterioration over time. With its decay, later on. No.
When it will stand thus in its putrefaction, it will belong. To whom?
It doesn't matter. It has nothing to do with itself. Look at this dark-
ness around us, so thick, we shouldn't complain about it anymore,
see how we read right through it. You should come with me to the
dark and deserted room, no longer be afraid. You should no longer
be afraid. You were too afraid. Moscow can no longer understand
Gdańsk, how could it? How could it understand Gdańsk? How?
This movement of the sea, the wind? This quiet strength? This love?
Moscow, that thing there, how could it? In 1946, yes, that's right.
The name written on the tomb is Akhmatova, Anna, banned from
publication. She would have been a hundred years old. This ban has
been in place since 1946, yes, it's true. Lived off of translation work
in a maid's room. The greatest poet. Gdańsk. No, nobody knows
why. Yes, it was in 1947. The name written on the tomb is Osip
Mandelstam. The greatest poet. Yes, banned from publication.
Gdańsk, Moscow, smiling back at him, how could it be? Two-hun-
dred and sixty million inhabitants. Nobody knows why, all of a sud-
den, a light appeared on the North Sea. It occurred at the center of
the darkness, do you remember? Hope? No, no. I don't think there's

anything more pessimistic than Gdańsk. Except this love I have for you that I know is an illusion, and I know that through this apparent preference I have for you I love nothing but love itself, not yet dismantled by the choice of our story. Gdańsk, how could Moscow ever understand Gdańsk? Gdańsk is so cheerful, so light, free, almost futile, yes, disparate, wild, tender, a crowd contained in each of its people. Moscow had accepted Gdańsk because Moscow had not understood Gdańsk. Like the deaf, you know, who answer, out of fear. Baudelaire. Mallarmé and the dead of Russia ... Why do you want to die? Why not? It's true, why not? We know history like rabbis know the Law. Come and see, everything is clear all of a sudden, the sea, the sky, the sea ran wild at sunrise, it turned mean and dark and here it is now, happy. It has no spirit, no intelligence, no heart, the sea, it's nothing but this tangible future, with no way out, no end. Gdańsk is mortal, it's the child with gray eyes, it's this. Like you, this.

10

The September tides are here. The sea is white, mad, mad with madness, with chaos, it struggles the whole night through. It charges at the piers, the clay cliffs, it shreds, it guts the blockhouses, the sands, mad, you see, mad. We shut our houses, we bring in the sailboats, we shut it all, it takes, returns, gathers, we sleep on its litter, the thunder of its depths, its wails, the long moan of its insanity. In the morning the sea always dies down. And then always, yes, as soon as the night wind comes, look, it starts up again, yes, as soon as the night comes, it rages on and on. I am in the black room. You are here. We look outside. The sea and the movement of the two distant shapes of the young girl and the child, they walk along the whiteness, on the nakedness, on the beach. They don't come any closer, they don't speak. There's no wind, it only comes at night with the changing of the tide. We are locked into the space of the sea, with its madness. It doesn't want to cross this equinox line, this equality between day and night. This astral angle, it doesn't want to, this rule of the sky, this law, it doesn't want to, this equator sun, every time it

rages on, carried away by the grip of its own power, its waters heaving toward the origins of the world, it wails. The beach is empty like the room. The young girl and the child are alone. I watch them in your presence. You who know the story, you without whom I would say nothing about it. They walk along the whiteness bathed in the white sun that now and then plunges into the black holes of the sky. At the top of the hill, the tents have been dismantled. Some buses arrived in the late morning, the children's suitcases were put inside. They're waiting for the time, four o'clock, and for the children to return. She went off to the beach. Without warning, she went off with the child. Come. From the top of the hill all eyes are on them. Fear. They say: She will not return the child. They say: She will kill him, kill herself. They say: They're not leaving the beach, as long as they don't leave the beach there's nothing to fear. There's a bright light over vast stretches of the sea, on other parts it rains, we can see transparent walls of rain streak the sky. They walk through the rain and the sunlight, they walk and I watch them from the black room. I see them clearly. I see the gray of the child's eyes filled with the crystals of his gaze, their wet brilliance, their flesh, I see the deep and unified gray of the sea, I see the shape of their bodies, the places of falling rain and the places inked with the rain to come. I watch them. You watch me watch them. Like them we are separated. They said: The buses will leave around four in the afternoon. She walks ahead of him. He follows her. They don't speak. You say: What were

we talking about in the black room? Today I can't remember. I say the same as you, that I can't remember. About the events of the summer probably, about rain and hunger, about the bad weather, you remember, that persisted day and night with the wind, the cold, about the heat, about those hot nights that seep out of those August days, about the cool shadow of the walls, about those cruel young girls with their unsettling curves doling out desire, about those hotels, those halls, those hotels, those abandoned rooms where love and books were made, her martyr's room, those painfully slow nights, you remember, when they would dance before him, yes, it's true, he who was tortured with desire and pain, nearly dying of it, in the wild ecstasy of that death. About Mozart too and the midnight blue over the arctic lakes, about the midnight-blue day over the voices, hearts trembling with it, over the voices of Mozart. And about your way of doing nothing, about her way of waiting, and about your way of waiting too on the couches facing outside. About Poland and about God. About death, too, and the postcard the child brought back from the store for her to write a date and the place and time they would meet, for the child does not yet know how to write, nor read nor anything, he knows nothing yet of these things he will now know very soon, in a year at the most, and for forever after that, until his death. At the top of the hill, fear. They're not visible anymore, they're past the beach cabanas, they're past the dark pavilion of September, the red flag signaling danger, we wait and we see

that no, they're reappearing, they haven't continued on toward the mouth of the Touques, they're returning, yes, they're returning to this side of the world where the buses have come to take the child away. There, I see them, I see her, singing, I hear the song she sings to pass the time until the buses leave. She doesn't sing the words, only the tune, mouth closed. She walks far from the child's body, she doesn't look at him. The child follows her, he walks far behind her, he knows that she doesn't want him to approach, he knows it, he watches her, he knows that she will not turn around. Singing the song imperfectly, sometimes stopping and beginning again at the right place, as if she had been singing all along, moving with the song, a syncopated rhythm, a deadly suffocation that stifles her voice. He watches her. She won't turn around anymore. Has she already seen him for the last time? Has it already happened? Will she look at him one more time? I don't know. I look at you. You don't know. I locked you inside the black room too. In the limitless space of the sea I have locked you in with the child. It's done. The black color of my closed eyes, these shocks to my heart, your definitive likeness. To pass the time, that's what she said, before the buses leave she sings to pass the time. The child walks toward her a little faster, he reaches her, reaches her hand, touches it, he tries to hold it but this hand remains cold and dead, open. She did not hold the child's hand. So the child stopped. He watched her continue on, he watched the sea and then he set off again behind her, he caught up

with her, he kept the distance she wanted him to keep from her. I
remember that one night, at the start of the summer, she'd asked
him: What do you love the most? He had tried to understand the
question, he had tried again and then he had said: I don't know.
Then he had asked her what her answer was and she had answered
with the same slowness, she had told him: Same as you, the sea. She
had waited. Did you already know? He had nodded, yes. It was after
she had sung the song for the first time. I can no longer distinguish
your body from the child's, I no longer know the differences that
unite and separate you, I no longer know anything but your same
gaze looking out toward that forever uncertain horizon where you
head straight to die before coming back and seeing. I no longer
know the difference between the child's exterior and the child's in-
terior, between what envelops and carries him and what separates
him from it, perhaps this heart, cloistered in that frail and warm
body, perhaps only this, this provisional difference, yes, this, noth-
ing else, this faint beating that's his alone and not the immensity of
its consequence. I also no longer know the difference between
Gdańsk and God. Nor the differences between those tombs in the
East, the Soviet lands of Death, between those lacerated poems,
buried in the lands of Ukraine and Silesia, between that mortal si-
lence of the Afghan land and the unfathomable wrongdoing of that
same God. Nothing. I placed my mouth on Gdańsk and kissed you.
No, the young girl did not look at the child again, as if he didn't

exist, as if he had never existed, as if he were being punished for being kind to the point of being cursed for it, as if he had never existed, yes, it's true, never, never, as if the very idea of his existence had never occurred to her, as if you did not exist. The child withdrew his hand, he stopped, he didn't understand who she was, who she had become. And then he started to follow her again. The summer turned gray, the sun set. The Antifer oil tankers were still in a single file facing Le Havre, will return tonight with the high tide, will be left there abandoned by us to the agony of these last days. Shock in the eyes of the child because her hand did not grasp his, did not take, as if nothing had happened. In the black room nothing else happens. Everything would be possible in the fallout of a single word that I don't know how to write and that would describe the forever approximate understanding of this despair. The child sees that this is beyond his capacities of understanding, he looks at her, he sees that love can be expressed in the reversal of its power, withdraw from itself and silence itself more violently than it could express itself. And so there is the sea and the wind, and the rain, and the strong waves, and the burning sand, and there is also this harsh and deaf woman, who sings badly, with her cold and open hands, pale with suffering, whose side he doesn't ever want to leave. And now the child joins the young girl's distraught wandering, her betrayal, he watches her shape as she walks, each footstep carrying her to the next as to the last in a rhythm that constantly breaks off and

begins again. He glimpses what he does not yet understand, he sees what he does not yet see in an opaque clairvoyance that fills his eyes with tears. She has stopped singing and asks him if he would like her to tell him the story of David, the child from the unknown island. She does not turn around. He says he doesn't want her to tell it. She says: I'll tell you when you have to make your way back, the bus will call for you. She says that she's not a good singer but she can tell him a bit of the story before the time comes, you know, the one about the spring and the shark. So he says: If you want. And so she says that one day the shark showed up and asked David to come and take a stroll with him through the ocean, that he wanted to show him a large meadow on the sea, a sargassum meadow, the deep jungle of shipwrecks, and the eels and the blight of the sea-weed and the sea bogged down by this mass of seaweed, this dead zone of the world, where there is never any wind, never a single wave, only a prolonged and gentle swell, never any cold either, and sometimes the sea becomes white with the milk of a wounded mother whale who comes to die there and people bathe in the milk and drink it and roll around in it all together. Come, David. Come. And the shark cries and David doesn't understand why the shark cries. And all the animals of the island gather around David and surround him and begin their nightly grooming, rubbing up against the trees, licking their fur, smoothing themselves, and also licking David, their child. And the shark begins to cry as he tries to go onto

the sand to snatch David and he suffocates and returns to the sea. And David says to him: See, it's happening again, nobody ever understands what you want, I don't know what to do anymore. And the shark is crying and screaming that it's not his fault and asking the heavens to forgive him and starting back up again in that incomprehensible language, this time made up of the sounds of throat-clearing, shrieking, sobs. The young girl stops. And then the light turns yellow, bright—the young girl stops again—the entire sea is bathed in it, the island too, and the animals' fur, and David's gray eyes, and now the air suddenly echoes with a liquid thunder and the spring slowly drains from the Atlantic basin and spreads outward, always blind and suffering and weeping and so beautiful, she sighs and complains, she asks who's screaming in agony like that, says it's rude, that no one could hear anything anymore in the ocean basins. And then the animals proclaim in unison that it was the shark, who wanted to eat David. And David finally understands and feels sorry for the shark. And the spring also feels sorry for the shark and so do the animals and the shark feels sorry for himself too and the evening arrives and a sort of unforeseeable happiness settles over the island, and the spring, in her confined waters, in her tremendous skirts of water, draped in them, dances, dances the slow funereal passacaglia of the wind in the black night. The young girl goes quiet. She says: I don't know the ending. The child says that two years had gone by, that she had told him. She says she remembers, yes, that's right, two years. That a boat had passed by. That it

had taken David on board. The child asked if the spring had died afterward. She said no, that the spring couldn't die, that the spring didn't know it but she was immortal. Not dead even now? asked the child again. No, never dead, never. The young girl said: I'm going over to the tennis courts, I'm going to sleep. She said: You'll head back along the boardwalk. She went to the tennis courts. The child saw that she was on the brink of death. She collapsed onto the sand and she remained collapsed there, facedown on the ground. The child is standing up, he remains there, motionless near the outstretched body. From the hill people are still watching. They say: The child isn't leaving, she's lain down on the sand, he's not leaving, we have to call him. A call made its way down the hill. The child didn't hear it, it seems, he now circles the outstretched body as if he's trying to join it, to lie down alongside it. She didn't hear it either no doubt. There's another call, slower, very soft. The young girl says: Go away. And so the child stops circling the body, he looks around him at the deserted tennis courts, the empty villas, the outstretched body with no strength and no voice. He said: Not yet. A third and longer call was lost at sea. She said: Go away. The child looked around once more at the vast desert of summer. Go away. He said nothing else, he waited some more and then he did as she asked, slowly he began to walk up the boardwalk toward the hill. Head down, he doesn't look. Nothing else happens in the black room. Suddenly, the collapse of a span of time, the passage of the wind, that strangeness, impalpable, which filters through the sand, the

surface of the sea, the incoming tide. The child walks. He continues. We stand apart from one another. I close my eyes. You look for me. You say: The child is almost at the bottom of the hill. You say: She isn't turning around. I ask if you hoped to never see them again, neither the trace of his footsteps nor that of their bodies. You don't answer. You say: The child is still walking. You say: He's about to disappear. You say: He's gone. I say I love you. You say: Even if she wanted to, she wouldn't be able to see him anymore. You say: The child went up the hill, he's reached the buses. I opened my eyes onto the black of the room. You're near me. You say: She never turned around. That the buses descended the high hill overlooking the jetty. That they drove along the beach. That the tide is rising. That the body must have disappeared from the beach not long after nightfall. That it's raining.

NOTES & CONTEXTS

TK

TRANSLATORS' AFTERWORD

In "Reading on the Train," Marguerite Duras describes her experience of racing through 800 pages of Tolstoy's *War and Peace* as "a betrayal of the act of reading . . . I clung to a reading of the story told in the book at the expense of a deep and white reading without any narration, a reading of the pure writing of Tolstoy. It's as if I had realized that day and forever after that a book was contained between two layers superimposed with writing, the legible layer that I had read that day as I traveled and the other, inaccessible. That layer, completely unreadable, we can only get an inkling of its existence when we're distracted from a literal reading, the way we glimpse childhood through a child. It would take forever to explain it and it wouldn't be worth the effort."

Perhaps the greatest challenge to bringing Duras's prose into English is how freely her writing passes through this "legible layer" to immerse readers in an experience of the "unreadable," that deeper, more immediate state of existence. This is also the source of her work's intensity. As translators, the moment we try to capture

this fleeting quality in English, it falls apart. When we try to dissect it and piece it back together, it's suddenly gone. When we strive for clarity, those phrases that form a logic solely unto Duras, the deep current of her writing, seem to lose their glimmer, their truth. They cannot be pinned down because, like "streams, lakes, oceans . . . they flow."

Faced with this dilemma, our answer has been to let the mysterious remain mysterious. To let the flow keep flowing, and the strange remain strange. This does not mean that our process was analogous to Duras's own. Translation does not begin with a blank page; we start with all of Duras's words. The flow of writing is not our own, it is constantly disrupted through laboring over individual word choices. Through worrying that something won't be clear enough for our reader. Through editing, talking things out, then editing some more. Some people think of translation as making the unknown known. As translators of Marguerite Duras, we are expected to articulate her work's "inner shadow," the "brilliant magma" running through her texts that Duras herself could not explain.

Our guiding light throughout Duras's sentences, which turn tauntingly opaque when isolated from the rest, was her rhythm. Her incantatory rhythm that distracts you from any literal meaning, carrying you into the deep flow of her text, that inner current of genius. But since a rhythm cannot simply be imitated in a new

language, one of our greatest struggles while co-translating this text was deciding how to create a rhythm that sounded like Duras. Where was the compromise between following the French rhythm and finding a way to create something just as trance-like in English? We often disagreed over very small things. Should it be the child with gray eyes or the child with the gray eyes? If she repeats the French article in her long lists, should we necessarily repeat the English article? Does it create the same trance, or is it clunky and distracting in our text? We couldn't always employ the same building blocks as Duras did. One thing we never argued about: should *la mer* be sea or ocean? Sea. Always sea. She proclaims in *Practicalities*, "Few people have written about the sea as I did in *Summer 80.*"

Duras's newspaper and other nonfiction writings are perhaps the most radical example of her glimmer, her inner flow, precisely because they present themselves against a canon of conventional journalism. In this "subjective journalism," she casts judgment and proffers opinions, she delves into the psychology of her subjects, she guesses at their motivations, points out her own objections to the legal system. Duras was completely obsessed with crime, always jumping at the chance to write about some of the biggest criminal stories of the time, blurring her obsession into her reporting, muddling the boundary between fact and fiction, often going on to turn these real events into novels. For example, one of her most famous

newspaper articles, "Horror at Choisy-le-Roi," was the inspiration for *L'Amante anglaise* in 1967 and *The Viaducts of Seine-et-Oise* in 1970.

Summer 80 was conceived as a looser project, to document Duras's summer in newspaper installments, both the things she lived and what was going on in the world. In its jumping from observations of the weather, the sea, the children playing in the sand, to a fictional story of an impossible love between a young woman and a child in summer camp, to the strike in Gdańsk—it is exactly how she wanted to write, without any rules. She described the writing in a 1990 interview in *Libération* as "a kind of urgency, a language of urgency, no doubt dangerous." Dangerous because she thought of the story of the impossible love between the girl and the child as one of her most beautiful stories, and also one of the most daring. A sort of experimental laboratory for her writing, *Summer 80* was her first book to employ the first person, heralding a shift into auto-fiction that dominated her later works. Duras would draw again from the novella to write *Agatha*, and then *La Pluie d'été*, and then *Yann Andréa Steiner*.

In its utter refusal to separate fact and fiction, the real and the imagined, *Summer 80* is a bridge to what would become Duras's signature style, the flow of her writing, her "écriture courante." A writing that encompasses the you, the I, the real and the fictional, the hills and the sea, literature and politics, all things slammed

together, as they are in real life. And thus that summer a new kind of writing was born, a crystallization of what she had begun years earlier with her previous newspaper writings. This is the Duras we have sought to bring into English, both the legible and the inaccessible, the political and the personal, with all her strangeness and mystery intact.

BIOGRAPHICAL NOTES

MARGUERITE DURAS was one of France's most important and pro-lific writers. Born Marguerite Donnadieu in 1914 in what was then French Indochina, she went to Paris in 1931 to study at the Sorbonne. During WWII she was active in the Resistance, and in 1945 she joined the Communist Party. Duras wrote many novels, plays, films, and essays during her lifetime. She is perhaps best known for her internationally bestselling novel *The Lover*, which won the Prix Goncourt in 1984. She died in Paris in 1996.

OLIVIA BAES is a trilingual Franco-American writer and actress. She holds a Bachelor's Degree in Comparative Literature and a Master of the Arts in Cultural Translation from the American University of Paris. This year she wrote and starred in her first feature-length film, *L'Homme au piano*, a trilingual film set in Catalunya, which explores the relationship between language and memory. Her second bilingual (IT/EN) screenplay *Riches* was recently selected by La Maison des Scénaristes as one of 15 projects in development to attend the 2017 International Cannes Film Festival.

EMMA RAMADAN is a literary translator based in Providence, RI, where she co-owns Riffraff, a bookstore and bar. She is the recipient of an NEA fellowship, a PEN/Heim grant, and a Fulbright for her

translation work. Her translations include Anne Garréta's *Sphinx* and *Not One Day*, Virginie Despentes's *Pretty Things*, Ahmed Bouanani's *The Shutters*, and Marcus Malte's *The Boy*.

DAN GUNN is a novelist, critic, and translator, as well as being one of the editors of the four-volume *Letters of Samuel Beckett* and editor of the Cahiers Series. He is Distinguished Professor of Comparative Literature & English at the American University of Paris where he directs the Center for Writers & Translators. He was designated in 2017 as editor of Muriel Spark's letters.

DOROTHY, A PUBLISHING PROJECT

1. Renee Gladman *Event Factory*
2. Barbara Comyns *Who Was Changed and Who Was Dead*
3. Renee Gladman *The Ravickians*
4. Manuela Draeger *In the Time of the Blue Ball*
5. Azareen Van der Vliet Oloomi *Fra Keeler*
6. Suzanne Scanlon *Promising Young Women*
7. Renee Gladman *Ana Patova Crosses a Bridge*
8. Amina Cain *Creature*
9. Joanna Ruocco *Dan*
10. Nell Zink *The Wallcreeper*
11. Marianne Fritz *The Weight of Things*
12. Joanna Walsh *Vertigo*
13. Nathalie Léger *Suite for Barbara Loden*
14. Jen George *The Babysitter at Rest*
15. Leonora Carrington *The Complete Stories*
16. Renee Gladman *Houses of Ravicka*
17. Cristina Rivera Garza *The Taiga Syndrome*
18. Sabrina Orah Mark *Wild Milk*
19. Rosmarie Waldrop *The Hanky of Pippin's Daughter*
20. Marguerite Duras *Me & Other Writing*